CREATIVE, NOT FAMOUS
THE SMALL POTATO MANIFESTO

AYUN HALLIDAY

Microcosm Publishing
Portland, OR

Creative, Not Famous: The Small Potato Manifesto

All text is © Ayun Halliday, 2022
This edition is © by Microcosm Publishing, 2022
Cover design by Joe Biel and Ayun Halliday
Edited by Alexis Orgera

First Printing, May 10, 2022

For a catalog, write
Microcosm Publishing
2752 N. Williams Ave
Portland, OR 97227
or visit Microcosm.Pub/SmallPotato

ISBN 978-1-64841-059-8
This is Microcosm #489

To join the ranks of high-class stores that feature Microcosm titles, talk to your local rep: In the U.S. **COMO** (Atlantic), **FUJII** (Midwest), **BOOK TRAVELERS WEST** (Pacific), **TURNAROUND** (Europe), **UTP/MANDA** (Canada), **NEW SOUTH** (Australia/New Zealand), **GPS** in Asia, Africa, India, South America, and other countries, or **FAIRE** in the gift trade.

Did you know that you can buy our books directly from us at sliding scale rates? Support a small, independent publisher and pay less than Amazon's price at **www.Microcosm.Pub**

Keep an eye out for The Creative, Not Famous Workbook coming in Fall 2022!

Library of Congress Cataloging-in-Publication Data: 2021050783

MICROCOSM · PUBLISHING

MICROCOSM PUBLISHING is Portland's most diversified publishing house and distributor with a focus on the colorful, authentic, and empowering. Our books and zines have put your power in your hands since 1996, equipping readers to make positive changes in their lives and in the world around them. Microcosm emphasizes skill-building, showing hidden histories, and fostering creativity through challenging conventional publishing wisdom with books and bookettes about DIY skills, food, bicycling, gender, self-care, and social justice. What was once a distro and record label was started by Joe Biel in his bedroom and has become among the oldest independent publishing houses in Portland, OR. We are a politically moderate, centrist publisher in a world that has inched to the right for the past 80 years.

Global labor conditions are bad, and our roots in industrial Cleveland in the 70s and 80s made us appreciate the need to treat workers right. Therefore, our books are MADE IN THE USA.

CONTENTS

INTRODUCTION

Art is sending the message that life has merit, that people have merit. I think we should see things that make us all want to go out and live better and share the good things we have seen. I think we should, without ever meeting, let it be known that we are here to support and protect each other.

 —Marlon Brando in an interview with James Grissom

Disclaimer

Few among us set out to be a small potato.

Most of us go into the arts with some sort of vague (or explicit) hope that our efforts will be noticed and rewarded. That we will be deemed worthy in a quantifiable, highly public way. That it's only a matter of time.

Turns out cookies rarely crumble that way.

Looking at it through the lens of history, most artists, performers, musicians, writers, filmmakers, dancers, and clowns have not been big bananas but, rather, small potatoes, strivers who don't abandon their creative pursuits just because they fail to become rich and famous.

Imagine that . . .

How many celebrities could muster the grit to persist in the face of such crushing public indifference?

The secrets spilled on these pages are spilled by small potatoes, for small potatoes.

My hunch is this book will best serve those who've logged at least a decade's creative toil without clearing the arbitrary bar that constitutes "making it" in the eyes of the public, press, parents' friends, and occasionally, parents themselves.

If you are a creative, freshly minted adult who has just received this book as some sort of well-intended, or possibly passive-aggressive graduation gift, we hope you will not hold it against us.

One day in the not too distant future, you may find yourself in need of our philosophical musings, universal admissions, and hot small potato tips.

Whenever you're ready . . . gooba gabba, we accept you.

Who You Calling Small Potatoes?

There are so many excellent things about being a small potato! Also days when it feels pretty dismal, and it's those days that pointed to the need for this manifesto. We small potatoes contain multitudes, to cop a phrase from Walt Whitman.

The small potato enterprise that's brought me the most consistent satisfaction is *The East Village Inky*, a handwritten, hand-illustrated autobiographical zine that I've published more or less regularly since 1998.

But I've also dipped my toes into songwriting, filmmaking, a daily photography project, animation, puppets . . . lately, I traffic in comics, essays, and a type of theater of interest to only a handful of the theater-going populace (which is really saying something).

I'm riddled with ideas, the great majority of which lead nowhere. Luckily, they're an invasive sort of weed. They keep springing up.

Were we to conceive of small potato-hood as a pathological condition—which I don't, so let's not—that sort of chasing about would be viewed as symptomatic.

I definitely don't relate to tales of single-minded ambition, but maybe that's just me.

Because there are so many of us, being a small potato should never be viewed as a one-size-fits-all proposition.

There are way more perspectives than the thirty-five shared in this book. With luck, you'll find one or two contributors whose experience and advice will help you stay the course in an age dominated by YouTube stars, social media influencers, and TikTok royalty.

Viewpoints will conflict, contrast, and converge as we grow this Small Potato Manifesto from the ground up. It's exciting. Possibly harrowing at times, but we'll get through it.

Let's start by attempting to define the term . . .

Potatoes Defined

To be a small potato in the arts is to be underpaid and relatively unknown.

—Heather Riordan, 56, Actor, Musician, Occasional Writer

Small potato means you're a root vegetable with lots of nutrients hoping a few brave foragers find and dig you.

—Rob Ackerman, 62, Playwright, Prop Master

To me, being a small potato means that I value small things, I value intimacy, I value places and spaces, and I understand that the audience for my work will never be that big. To be in a place, communicating something to an audience, to make a beautiful thing and give it away, to practice. I still love small live things—house shows, puppet theater, small theater, intimate performances, close connections, unimportant ordinary stuff, a little show in a converted school bus, a small quiet white room with very low benches and a crowd of three- and four-year-olds listening and watching. Music and theater that are important to children make a lot of sense to me, and move me uniquely.

—Emmy Bean, 39, Singer, Musician, Performance-maker

The fact that I produce any kind of cultural thing at all and put it out there and don't have a huge audience makes me a small potato, I guess. My zines sell just well enough to keep them in print but not well enough to do any more than cover costs. My podcast gets listened to by my core group of friends and that's it. We have done absolutely nothing to monetize it. It's 100 percent free and we really just do it because we think it's fun. It's a horrible business model. I have to pay to keep the site up. But I enjoy it.

—Liz Mason, 45, Writer, Zine Publisher, Podcaster, Performer

Right now I feel like being a small potato is a good thing. It means I can make my thing for the people who enjoy it. I've been lucky, too, but I would rather make my thing for the people it works for than for "everyone."

—Drew Ackerman, 45, Bedtime Storyteller, Podcaster

I don't have great exposure, and I've moved from discipline to discipline trying to find something that fits in the long-term. Perhaps no one thing will, but everything will synthesize over time into a Mega Integrated Art Form that is just for me. I know that if I committed myself hard and fast to one realm I could grow to be a larger potato, but as it so happens, I haven't. Maybe with fiber and textiles, it is different. I don't rule anything out.

—Connie Fu, 27, Artist currently focusing on textile and fiber art

I define being a small potato as being an active creator and artist despite having a full-time day job to afford pesky things like rent, and thus being limited in terms of working towards big potato status.

—Bob Laine, 55, Actor, Poet, Playwright

I self-publish. My books are in my Etsy store and shops that I choose. They are not available on Amazon or in any large mass-market way. I am not out to "take over the world" or become "famous." I like a laid-back approach to my projects.

—Delaine Derry Green, 49, Visual Artist, Comics Publisher

Recently, I realized that my trouble is that I am anti-establishment. This is not something I was conscious about. I used to hate when they would make us take naps at band camp and we couldn't leave our bunks. My teachers in high school thought I was too "radical." And I accidentally carried a chip on my shoulder into my artistic career. So yeah—I like the black box. It is where I belong. I need to be able to touch the set pieces with my hands.

—Meghan Finn, 39, Theater Director

I am in the trenches all the time, wearing all the hats, self-managed, a small enough operation so it's basically feasible, but caught in the catch-22 of not being able to grow much bigger because I'm at the limits of my capacity.

—Ellia Bisker, 40, Musician, Singer, Songwriter, Performer

I'm low budget, I guess. I am always trying to see what I can pull off for the least amount of money. I'm not the biggest in the world, and I don't care. I just dream of it one day being sustainable and successful enough to support me and my best friend in the rural Midwest with the assistance of odd jobs and welfare, y'know. I don't want to own a fucking yacht or have two billion Instagram followers.

—Anonymous Zinester No. 1, 28, Zinester, Distro Owner, Layout Artist, Publisher

I've never been "the chosen." I've always been the scrappy, loudmouthed, slightly abrasive bull in a china shop fighting for opportunities.

—Akin Salawu, 45, Writer, Editor

Unless you're on the silver screen or Broadway or one of like five other prestigious venues, I think a lot of what is made here in NYC falls under the term small potato. There is just so much art competing for our attention in a city like this that so much of it, even some of the great stuff, does not get the recognition or the attendance that it deserves.

—Shelton Lindsay, 32, Writer, Performer, Producer, Designer

A small potato is maybe like an underdog? I'm not as famous as some people I know who well deserve it. I also don't have the advantages of some dilettantes

who like to make everything look like it comes super easy to them, but it's actually privilege.

—J. Gonzalez-Blitz, 47, Artist

Small potato: a term that refers not to the potato but more to the relative distance between the potato and the observer. In proximity to the small potato, one would observe that it is not small at all.

—Anthony Wills, Jr., 45, Performer, Singer, Artist

Instead of calling myself a small potato, I'd say my medium of choice is a small potato, in that it is very accessible to audiences and cheap to produce. I have very ambitious goals, and the projects I draw would be very expensive if I were making an animated film, for instance. But you can create a fully-formed world in a comic and essentially do it by yourself. I love to collaborate, but bigger projects can be so much harder to fund and realize.

—R. Sikoryak, 55, Cartoonist, Illustrator, Writer

A "small potato" artist is someone who intentionally farms a decidedly narrow stretch of cultural land, an artist whose goals are specific and marginal but deeply realized. If artists can be sorted into Isiah Berlin's foxes and hedgehogs, small potato artists are hedgehogs.

—Todd Alcott, 59, Graphic Designer

Small Potato: a potato that has yet to reach its highest realization, still growing until dead.

—Maria Camia, 27, Visual Theater Artist

1. THE PERKS OF BEING A SMALL POTATO

Creative Control

That's what topped the charts, chopped the tarts, and honked the loudest horns when a bunch of us started batting around candidates for the absolute best part of being a small potato.

Control over everything that happens. I make stuff, help others make stuff, it's simple and everything seems possible.

—Nick Balaban, 57, Music Guy

I can do whatever I want.

—Shelton Lindsay

I can say whatever I want.

—Akin Salawu

I'm free!

—Connie Fu

Hey, check out what happens if we combine Connie's thoughts on the best part of being a small potato with her thoughts on the most challenging thing about being a small potato!

* Fortunately not the sole perk of the office . . .

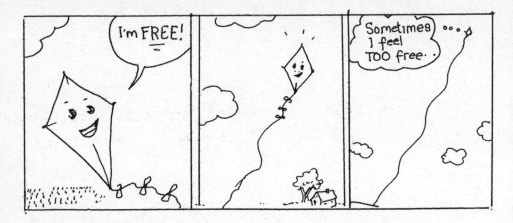

Be Yourself

Nobody is exactly me. I fill my own exact niche, and I'll be honest, I'm not for everybody. I'm probably not even *for* that many people. I have made peace with that. I have found that to be true in my personal life, and I have found that to be true in my art life. Also, my early zines, the ones where I wrote stuff I'm embarrassed about now? Thank god the entire world has not read those. And when I do make a dud now, in print or audio, I can tell myself, "You know what? It's not like my brand's stock options are going to go down because I phrased that sentence awkwardly."

—Liz Mason

I get to do whatever dumb bullshit whenever I want, and nobody is going to stop me. I love gimmicks and concepts and aesthetics, and you lose a lot of that (and all the control over that) when you're running with the bigger dogs. I get to do

things my way all the time and run down whatever avenue I want, and nobody holds me back.

—Anonymous Zinester No. 1

Um, does anyone out there in Reader Land *not* know what a zine is? I probably should have checked in about this prior to the word's first four appearances.

There's no shame in not knowing. We've all got our subcultures, and the vocab doesn't always overlap.

Zines have tiny print runs and tiny audiences. Bookstores that specialize in zines cater to a small subculture.

—Steven Svymbersky, 59, Zinester, Bookstore Owner

Write "zine" on a chalkboard, and the uninitiated invariably sound it out so it rhymes with "wine," as opposed to the last syllable of "magazine," which isn't really a rhyme, but I digress. Not everyone aspires to a life in the arts, but most people have some concept of what a musician, visual artist, or dancer does. Even my grandma's bridge club had a ready frame of reference, thanks to Percy Faith, Norman Rockwell, and Bobby and Cissy from *The Lawrence Welk Show*. (Not the freshest references, I know. Hey, it's cool. Your failure to recognize them confirms that most big bananas get smaller

@theMARICAMA

and more potato-like with every passing year.) "Zinester" still leaves people scratching their heads. Our reach is a lot more niche.

By the time we finish building this manifesto, you will not only be conversant in the world of zines, you will probably have banged out a couple of your own.

In return, feel free to teach me how to screw your mouthpiece in. (Just a stab in the dark. Is jazz flute your thing? Please say yes.)

Our approximate size and soon-to-be shared manifesto are not all we have in common. I'll wager we're all a little rough around the edges, and that's what makes our work so compelling to the people who *do* respond to it.

Every generation has at least one giant obelisk of a banana with a small potato soul, steadfastly defying the suits who sandblast their image—Billie Eilish and, well, I was gonna say Amy Winehouse, but . . . that didn't turn out so great.

Do you share my impression that it's a constant struggle for big bananas, particularly young ones, to escape the girdle of inauthenticity?

It's a battle we small potatoes need not fight . . . so don't listen to any internal corporate suits urging you to make yourself more "relatable."

Relatable to who? A hypothetical public whose tastes are in no way fixed? By the time you're finished trying to make yourself palatable to them, there will be a whole new hypothetical public you'll be expected to alter yourself for. To thine ownself be true.

The best part of being a small potato is learning how to weed myself and growing to be my best self.
—Maria Camia

Your Time is YOUR Time

The best part of being a small potato is that there's no pressure to keep a constant upward trajectory. Things take the time that they take. I make work on my own terms. I don't need outside validation (although it is nice sometimes, lol).

—Anonymous Zinester No. 2, 28

This is not to say we don't have deadlines. We do, but mostly it falls to us to set them . . .

It's also on us to grant ourselves an extension, should we need more time.

Be merciful. Give yourself more time.

This book wound up requiring more time.

Fortunately, our publisher is a champion of small potatoes everywhere, and when we came to them, hat in hand, they said they'd rather have a quality product than a rush job.

That was a revelation.

I still wish I hadn't blown that deadline, but only because I try to hold myself accountable when it's a group project.

When I'm flying solo, I definitely lean toward quality product over rush job, but sometimes I need reminding that there's no disappointed party pounding on the door, screaming that I'm late. There's less external expectation. You have to be the one with the ambition and expectation.

—Rachel Kramer Bussel, 44, Writer, Editor, Writing Consultant

Make What You Want

> The best part of being a small potato is that I don't have to ask, "Is it okay to put this out or make a show about this?"
>
> —Drew Ackerman

How many creative ideas have we given up on because we sought permission?

There's little to gain by sitting around waiting for the big infernal machine to make up its mind about us, to paraphrase the late great Spalding Gray, a storyteller, like Drew.

Some small potatoes experienced a paralyzing amount of shame in childhood. If you're one of those, please grant yourself permission to explore whatever subject you're drawn to, vigorously, publicly, in ways that may confound expectation. Even if it's gross or embarrassing.

Especially then.

Once upon a time, before this magical thing called the Internet, there was an equally magical organ of communication, *Factsheet Five*. It came out several times a year, pages and pages of densely packed zine listings on smudgy newsprint. Each capsule description included the zine's price and the publisher's contact info.

Placing an order involved stuffing a couple of bucks in an envelope then firing it off in good faith. Sometimes it took months for a requested title to show up in your mailbox. I swooned over that thing like an early-twentieth-century farm wife poring over the Sears Roebuck catalog! Lace-trimmed slips! Deluxe butter churns! An abundance of interest and industry! Small potatoes were putting their work out into the world, as if—

gasp—their creative impulses and interests merited a wider audience . . . whether or not they ever found that audience is somewhat beside the point.

They were doing what they needed to do. Not just thinking about it. Putting it out there.

Even if it was gross or embarrassing.

Answer to Yourself

I suppose the best part of being a small potato is being unanswerable to anyone for anything. I started a theater company. The company consists of just me. No employees, no board members . . .

—Trav S.D., 54, Performer, Writer

Conventional success might not actually be what I'm after in the final analysis. I enjoy not having to pay for the excesses of large-scale success. I don't want to work under any pressure but my own.

—Karen Christopher, 57, Performance-maker

No wonder there are so many human interest stories about Wall Street traders abandoning their stressful, highly paid careers for humbler, more small-potato-esque pursuits (frequently involving cupcakes, for some unfathomable reason).

Hopefully they weren't shocked to learn how much time we spend juggling chainsaws on tightropes.

The best part of being a small potato: working from home and not answering to a boss. It's great answering to *nobody*!

—J.T. Yost, 46, Publisher, Cartoonist, Illustrator

Don't give the money-people control over your creativity. Don't let them be the only ones to dictate the art that gets made and put out in the world.

—Christine Schisano, 36, Puppeteer, Puppet Designer/Builder, Writer, Actor, Producer

Staying relatively poor helps me not accumulate debt or loans to repay. I don't pay a lot of taxes, and I qualify for Medicare. Low expectations mean low stress.

—Steven Svymbersky

Fly Under the Radar

Okay, okay, we get it! Being a small potato is the greatest. But c'mon now. Isn't it maybe a little *less great* than being an American sweetheart?

The best part of being a small potato is having a little bit of privacy. Imagine being Jennifer Aniston! That level of fame (or even anywhere near it) sounds just horrid.

—MariNaomi, 46, Cartoonist, Podcaster, Database Admin

You don't get recognized on the street. People don't want things from you (except when you are an Artistic Director and they start surrounding you like vampires, which is weird). I actually feel kind of sorry for the famous person whose kid goes to my kid's school. He doesn't have the autonomy to just do his kid's kindergarten drop-off like a normal person. I also like to get lost in cities while on tour and whatnot. It's fun to be a regular person.

—Meghan Finn

I, too, value the ability to wander at will, communing with the general public, though I'm not averse to the idea of being plucked from obscurity late in life, like Clara Peller, who became an unlikely star at eighty-one for bellowing, "Where's the beef?" in a series of fast-food commercials.

That phrase is probably chiseled on her tombstone.

How luxurious to quietly contemplate a beautiful, broken-penised bit of antiquity without some museumgoer shooting over-the-shoulder selfies whose real subject is you. How enchanting to beam at a stranger on mass transit because the book in their hands is one of your favorites. How joyous to sing and dance when that ridiculous disco tune that reminds you of junior high starts playing in the produce aisle. Yes, some big bananas buy their own groceries, but you'll never catch them doing the Hustle next to a bin of cantaloupes. Wouldn't want to risk deactivating the identity-concealing powers

of their baseball caps and indoor shades. Thanks to a recent, highly contagious, airborne pandemic, the entire population knows what it is to feel freaked out by proximity to ordinary humans. Try living your whole life that way!

Don't forget to factor in the horror of waking to the news that you're ugly, untalented, and emotionally unstable—not according to some random drunkard whose advances you've rebuffed, but rather a respected entity with an enormous megaphone and a circulation in the bazillions. Think of the social traction an obscure gossip site could get by posting a photo of you looking well-fed in your bathing suit.

As for discreet canoodling . . . forget about it!

People behave most naturally around small potatoes *because* we are not famous (or because they haven't researched us). They behave around us like they would anyone else. We get to see more of their "true colors."

—Stephanie Summerville, 54, Actress, Storyteller

Connect with Like-Minded Humans

I love personally knowing people who know my music and the performance work I've made, feeling connected to them because they are also my friends and neighbors. I love feeling the potential energy of having big stuff inside me and putting it into small containers.

—Emmy Bean

Bless every friend and neighbor who makes the effort on our behalf, though if you're like me, the majority of your friends are also hard-hustling small potatoes. Having heard,

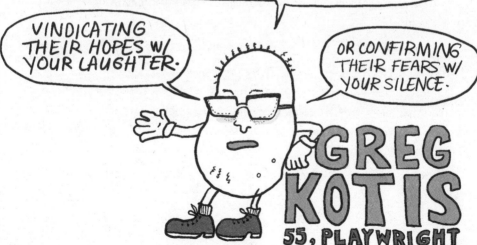

WHY PLUNK DOWN YOUR HARD EARNED DOUGH & TROT OFF TO SOME BLACKBOX, HIDDEN AWAY BESIDE ONE OF THE LAST ADULT VIDEO STORES IN NYC TO SEE A DUMB PLAY? NETFLIX & ITS ILK ARE EASIER & CHEAPER. ONE ANSWER: WE'RE MORE SEPARATED, MORE ALIENATED FROM EACH OTHER THAN EVER BEFORE. THEATER OFFERS A CHANCE TO JOIN SOME BONAFIDE, IN-THE-FLESH HUMAN BEINGS, TRYING TO MAKE A LITTLE SENSE OF THE WORLD. THE ACTORS ARE AS ACUTELY AWARE OF YOU AS YOU ARE OF THEM, A FEW FEET AWAY—

VINDICATING THEIR HOPES W/ YOUR LAUGHTER.

OR CONFIRMING THEIR FEARS W/ YOUR SILENCE.

GREG KOTIS
55, PLAYWRIGHT

27

seen, and read ample quantities of our shit, they aren't always up for providing the kind of feedback we crave.

So, bless the scrum.

Bless every stranger who reads the latest issue of my zine and gets in touch to share their favorite bits.

Bless the subscribers and the resubscribers, even those who say, "I couldn't believe it when I found out you're still doing it!

Bless anyone who posts a selfie with their pet rabbit and a familiar envelope so I'll know the zine they ordered arrived safe and sound (and also that they have a pet rabbit).

These small-scale human interactions are reassurance that my dust speck doesn't exist in a void.

Knowing my tiny yawps haven't gone unheard is my personal favorite part of being a small potato.

Interacting with the scrum can also be nerve wracking. Especially in performance-oriented situations where there's no delay between putting it out there and the scrum's reception of it. Some nights, the scrum turns its collective nose up at the slop they see me pouring into the trough of Art.

What's the tip-off? The stinginess of their response. "Crickets," in thespian-speak.

Whatever our discipline, we all have bummer nights in the merciless footlights.

It's hard to avoid letting that get you down. Just don't let it stop you from doing your thing.

People will respond . . . next time, tomorrow night, someday . . .

Their numbers may never be sufficient to sell out a blackbox theater, justify the purchase of a tour bus, or elevate you to Homecoming Parade Grand Marshall, but they will be enough.

Meaningful human interaction is not a numbers game.

It's the quality of the attention.

A knife that cuts both ways.

What you do is not about anything specious like money or praise, it's about nurturing, which is our most important task on earth.

—Rob Ackerman

THE SMALL POTATO MANIFESTO

WE RELISH THE FREEDOM OF OUR RELATIVE SMALLNESS

2. PAYING THE BILLS

Complete this sentence: The hardest thing about being a small potato is _____.

Money. But fuck it. Also everyone's obsession with money. But fuck it.
—Meghan Finn

That I can hardly afford to do the things I dream of.
—Shelton Lindsay

Paying the bills.
—MariNaomi

Sometimes it would be nice to have more money to do fun things that cost money or eat really good food that costs lots of money.
—Steven Svymbersky

Yeah . . .

Full disclosure: the money's not great.

Working for Free

Ah! We haven't frightened you away. Good. But will you work for free?

I do it all the time, if the project is something I really want to do. Don't get me wrong, I love being paid, but I love doing the work more!
—Bob Laine

Sometimes. Depends who the person is and what the project is. Some art is just for fun, and that's okay. Some art is done to support others, some art is done for the community. All of those things are real; however, it is important to know your worth and not undercut yourself.

—Shelton Lindsay

I don't think you can get great at what you do without working for free. The most important thing is to work as much as possible. Sometimes that means having to work for the biggest money possible so you can afford to work more. It's good to work for money in that it forces you to consider what people will pay for and how you can connect to others' needs and wants. As long as you *never* lose who *you* are in that process. Art and creativity are ultimately human needs that must be fulfilled, whether for an empty peanut bag or a mountain of gold.

—Nick Balaban

I absolutely HATE IT when people talk about doing work for free because of "the exposure." EXPOSURE IS A FANTASY. THIS IS NOT *42ND STREET*. I'll only do it if it's for a good cause, making a donation of my time and energy as opposed to writing a check. Many live lit events don't pay the performers. It's a crying shame that that's the business model.

—Edward Thomas-Herrera, 56, Theatermaker

Sometimes I'm fine with it, sometimes I am most decidedly not. If it's a passion project from people I respect or an event benefiting a nonprofit and the community at large, then I'm cool working for free. But I also really examine who's benefiting from work I do—if the answer is Somebody That Makes Way More Money Than I Do And Has Way More Privilege, then fuck you, pay me.

—Anonymous Zinester No. 1

I'm not against working for free, as long as there is equity. Are we all working for free? Or are most of us working for free and the organizer getting paid? Transparency helps. If you can see why you are not being paid, then it makes it easier. I'm usually just happy to be asked to participate. Getting money is a little cream in the coffee.

—Anonymous Writer-Performer, 58

I reckon I'll continue working for free for many of the reasons cited above and decline for many of the other reasons cited above.

Leaping from vegetable to animal for a sec, I've developed a fairly keen sense over the years of when I'm being milked.

If the hands on my udders are unfamiliar, are they being sufficiently gentle, patting my flanks and fluffing up my hay? If I'm being clamped into impersonal metal squeezers, expected to fill half a dozen cans before being prodded back down a metal chute with nary a word of thanks, they can consider the dairy closed from here on out. They're lucky I don't kick over the lantern and burn their barn to the ground.

Pay Your People

I produce a highly esoteric, low-budget, book-based variety show once a month. It runs about seventy-five minutes, and features six to eight acts. If there's no competition from the weather, some holiday, or the world of televised sports, *and* if, say, half of the performers have done some advance promotion to their friends, my portion of the fifty-fifty box office split with our host venue works out to about $175. Most of which will have already been divided into $25 pittances that I slip into handwritten thank you notes and

present with great ceremony (and transparency) to the participants, prior to the show's start.

Such are small potato economics. Some of the small potatoes who I'd like to book will not come out of the barn for such a paltry amount. Fair enough. Others, unused to getting paid, gape in delighted surprise upon opening their envelopes, having forgotten a pittance was coming their way. I get a good feeling knowing that pretty much every penny of my paltry earnings has been redirected to the people who help turn my cockamamie ideas into actual things.

If money is not an option, like when your budget's been eaten up by such non-negotiables as studio rental or printing costs, pay in the coin of the small potato realm: a homemade meal, comps, promotional back scratching, contributor copies, whatever skilled labor you can bring to your helpers' tables.

Don't let the paucity of your purse make you mean in the Dickensian sense.

Be at peace with none of your net profits making their way into your pocket. Should some of them wind up there, you're lucky. Sock 'em away for your next project. More likely, you'll continue to operate on the edge and in the red.

Either everyone gets paid or no one does. Payment is equal between equal collaborators making the work.
—Karen Christopher

For the TV show I'm writing, the money we raised and that I invested went towards gear, logistics, food, housing, and paying people who are doing the technical jobs like sound mixing, editing, and visual effects. The actors are all on deferred contracts, in the case that we make any money at all. When I do burlesque shows, it's usually a profit-share model where we guarantee *X* amount

to the performers. If we sell a bunch of tickets, we give people bonuses on top of that.

—Shelton Lindsay

I pay well in order to show collaborators and contributors that I'm serious, and I trust they will be, too.

—Nick Balaban

We're not gonna put this in the manifesto, but something to keep in mind, should your potato unexpectedly blow up: stay humble, stay inventive, but don't behave as if your bank account has not made the leap. Stop paying people in pizza. Find another way to feel young, punk, and scrappy.

Managing Your Money

You do not want to take money-related advice from me.

Seriously, my financial expertise fits comfortably inside that little circular indentation that allowed my peg-shaped Playskool people to be plugged into their vintage plastic dollhouse chairs. Those chairs were the perfect size for banking the two quarters my father gave me weekly, hoping I'd learn something about the value of money.

(Meanwhile, Patti Smith and Robert Mapplethorpe were dining on a single saltine and wearing coats to bed in their unheated East Village studio, after squandering their food budget on art books . . . ah, youth.)

My father saw my unwillingness to blow even a portion of my accumulated allowance on candy or dime store toys as evidence of Scottish thrift.

I see it as evidence of my ability to squirrel away and repurpose pretty much any memory from my childhood, no matter how tangential.

I suspect you and I share a flair for hustling and getting things on the cheap, but here's something I know for sure:

Geography, health, age, race, education, gender, immigration status, parental status—shit, even the number of siblings in our families of origin ensure that our situations and needs are unique.

I don't think it's such a hot idea for you to accept financial counsel from someone you haven't met in person, who thinks in terms of quarters and seventies dollhouse furniture, a former theater major who never quite mastered math, never took economics or statistics, a former waiter who is constitutionally unable to enjoy expensive restaurant meals.

I've encountered people who would make me feel like a failure for not supporting myself full time off my artwork. It never occurred to me to ask if *they* were, but they may not have been honest anyway. Who knows? There was definitely this point in the nineties and early two-thousands where I met people at different events who had this attitude that if you had to supplement your income with anything noncreative you were just a "hobbyist." I ran into another illustrator working a catering gig who made me swear not to tell I saw them there. Looking back on all this I wonder if this is really something these people believed . . . because none of it seems to be true. Before I got put on disability, I was always struggling to make ends meet—temping, bike messengering, working strip clubs, catering, art modeling, even the occasional legitimate job.

—J. Gonzalez-Blitz

Despite any romantic notions Patti's prizewinning memoir, *Just Kids*, may have put in our heads, a cracker-based subsistence diet, a dashing army surplus coat, and a reverence for Rimbaud will not see us through for long. Especially once the shit hits the fan, which, not to be too Chicken Little about things, it will at some point—if it hasn't already.

Maybe you're on top of your situation, able to balance your small potato doings with stable housing, a reliable source of food, good health and good health insurance, and plenty of nuts squirreled away for winter.

If you aren't, all I can say is look elsewhere. Find an expert. Someone who knows what the fuck they're doing. Someone who won't look down on you or the size of your purse. It's okay if they never grasp how deeply your sense of self-worth depends on your ability to make puppets from dryer lint, cat fur, and vintage spanking porn. Their animating principle need not be your animating principle.

Where to find this person? A bank. A storefront community organization whose windows are plastered with flyers for free tutoring, free mental-health assessments, free diabetes testing, and free legal advice for tenants.

If the thought of this is causing you to break out in hives, dip your toes in a website geared toward women in their twenties, or *AARP The Magazine*—both reliable sources of short articles on saving, stretching, and spending money wisely. It's not very punk rock, but you'll probably come away knowing how to throw a bridal shower on a budget and which college town relocating retirees will be flocking to next year.

THE SMALL POTATO MANIFESTO

WE RELISH THE FREEDOM OF OUR RELATIVE SMALLNESS WITHOUT HOPE OF WEALTH.

➌ THE PRACTICE

Doin' It

Kurt Vonnegut's novel *Breakfast of Champions* is peppered with his simple line drawings.

Along with the asshole, the beaver, and the wide-open beaver, the one I can't forget is a word picked out in theatrical bulbs:

Fairy Land is the invention of one of the characters, a disenfranchised recent parolee who longs for a world that is loving and just, unlike the one in which he dwells without friends or relatives, where people "put him in cages all the time."

The name he gives this better world is—you guessed it—Fairy Land, even though it's a source of embarrassment to him. I'm hunching many of our most private hopes and desires qualify as "childish" and way too embarrassing for public utterance. Rather than risk speaking of this deeply desired destination, he writes the name "in lights on the inside of his skull."

This excellent compromise inspired me to paint the inside of my skull with something I can iron onto an imaginary T-shirt.

In font and spirit, it takes me back to a thing I longed for but wasn't allowed to have. My mother felt strongly that nice girls had no business broadcasting vulgar sentiments in fuzzy, heat-sensitive letters stretched across budding chests.

This was a major social liability for my late-blooming seventh-grade self. My stock *plummeted*. It's okay. The experience, while far from pleasant, was beneficial to my creative development (and forging a healthy distrust of the mainstream). If I had it to do over, I'd hitch a ride to the Shirt Shack with every quarter stashed in my Playskool chairs.

I didn't realize that was a thing I could do. Now, I do. On days when my creative mojo is flagging, I look inside my skull and there it is, ripe for the picking. Who gets to do it? I do.

I didn't have a very clear handle on what "it" signified back in the Paleolithic roller disco era. Now I do.

"It" is potential. Exploration. Going all the way. All the wild weird fun stuff the squares don't think we should tap into.

That's what I want inside my skull. That's my beacon.

What's yours?

Jotting: Notebook vs. Phone

Ever start feeling like shit about yourself, reading one of those infernal interviews wherein some big banana divulges their creative process—how they rise before dawn, make a pot of black coffee, and sequester themselves to create until noon?

In the right (which is to say wrong) mood, my inability to do the same seems an enormous personal failing, rather than a case of differing dispositions and a grossly unequal distribution of personal assistants, personal chefs, personal trainers, and other assorted personnel.

Handling the details of our lives without much help means squeezing things in around family, day jobs, and other such obligations. Few of us can subscribe to a rigid regimen. It's okay. We just need to leave a few breadcrumbs.

I always have pen and paper with me for when ideas, lyrics, and titles strike.

—Lorijo Manley, 54, Singer-Songwriter, Musician, Writer, Actress

Carrying a notebook is an excellent, classical practice, especially if it's perfect bound, conjuring visions of Lost Generation Paris, yet easily procured in 99-cent stores, where their covers are enriched with sunny, batshit idioms. Sadly, carrying a little notebook doesn't pair so well with another practice of mine: running three or four big, sloppy bags simultaneously, their contents a ratty jumble of books, creased envelopes, single gloves, dead pens, grubby contact lens cases, and god knows what rattling around in ex-Altoids tins . . .

Everything I need is spread out between them, but the exact contents of any given one are clouded in mystery, particularly when I'm in urgent need of some essential item—keys, wallet, a crumpled scrap of paper on which a vital piece of information is ill-advisedly scrawled.

I know a lot of people prefer to enter that type of stuff into their phones. That only works if you can find your phone. Mine spends a lot of time on walkabout, ringer off, battery power in the single percentiles.

What I need is a more substantial version of those teeny tiny notebooks young ladies wore tethered to their wrists during the formal parties of a vastly more binary age, to keep track of the fellows to whom each dance had been promised.

I wonder what would happen if we forced ourselves to spend the final five minutes of any work session, even the impromptu ones, jotting down anything that seems germane, a rudimentary map to help us back onto the right road.

The words we emphasized in rehearsal. The title of a book we compulsively checked out of the library when we were children. A reminder to contact the musical historian who just popped into our heads. The pros and cons of each brush we tried. Ideas about timing, themes, quality of light, the meaning of life . . .

Sometimes I'll randomly run across an interesting historical event or person on the Internet and bookmark it, fully intending to circle back later and use it as the basis of a monumental one-person show incorporating puppets, projections, original songs . . . Alas, digital bookmarks are not a very good way to keep the spark alive for the long game. Some of the links are bound to go dead. The ones that survive have dulled, like taxidermied animals in a dusty museum case. Our own handwriting, our quirky diagrams and doodles make far better signposts.

Though I've never succeeded in keeping one consistently about my person, there are a number of little notebooks stashed under my bed and in the cabinets above my desk. Any given one of them makes for fascinating reading—for me, that is. Which is fine. Unlike a diary, a little notebook is never written with an eye toward posterity and possible wider readership. It's just a place to scrawl stuff we don't want to forget. It's an inadvertent time capsule, crammed into a trick peanut can:

- The address and hours of the thrift store where a potentially perfect prop was spotted, too bulky to haul home on the subway.

- The emphatic book recommendations of the host's drunken, effusive friend, whose only other lasting impression is their willingness to converse with us at a party where we knew no one.

- Lyric fragments from a song that stopped us dead in our tracks in a café or store. (Shazam that shit if you can find your phone, but also write the title down!)

- Three restaurants that sounded good in the distant neighborhood where a new friend's band was scheduled to go onstage at 9:00 p.m. on a Monday.

- Packing list for self-booked tours.

- Possible solutions.

- Poignant museum placard descriptions.

- Character names.

- Vet recommendations.

- Hospital room numbers.

Years from now, we—or possibly someone else—can flip that little notebook open and find that something within has alchemized into inspiration.

The same cannot be said for a phone, no matter how smart.

Now there's an addendum to Oscar Wilde's immortal line, "I never travel without my diary. One should always have something sensational to read in the train." Commit to daily entries, and you can bench press your journal should you leave home without travel weights.

For many of us, deadlifting a massive record of beliefs we no longer hold, persons we foolishly believed ourselves to be in love with, and all the baseless judgments of our youthful navels would be far less excruciating than reading those actual entries.

I keep a line-a-day journal for a bit of self reflection each day.
—Connie Fu

That has some prophylactic appeal. Write enough to remember and not enough to veer off into cringe territory.

Once upon a time, I was a pretty regular diarist. Having children clubbed that habit into oblivion though I've dutifully dragged the many hardbound and softbound volumes produced between the ages of twelve and thirty-one to every home I've lived in since.

I know what the Grand Banana of Organization, Marie Kondo, would say. Pitch 'em.

Of all the things these albatrosses spark, joy is very low on the list. Fear and shame dominate, especially when I picture someone other than myself reading them.

Actually, that cherry's probably been popped many times over. It's a rare Pandora who waits for you to die before cracking the seal.

And yet, I cain't quit them. What if I need them to verify something I'm working on, like when I was writing my travel memoir and couldn't quite recall the name of the picturesquely dumpy, ungoogleable, zero-stars Singapore hotel where I majorly pissed off an American ambassador's (kleptomaniac) wife? Mostly I skimped on such practical information. What little there is must be dug out from beneath a towering compost heap of feelings . . . whoa, whoa, whoa, feeeeeeeeeeeeeeelings

Venting those feels can be therapeutic, but thinking it over, I've identified three non-emotions-based reasons for keeping a daily—or more or less daily—journal:

1. Captain's Log

I refer you to *Diary of a Norwegian Fisherman*, a book my stepfather picked up in the grocery of the small Wisconsin town where he spent part of every summer. It wasn't so much self-published as self-published by a retired, history-loving descendent of the diarist. The fellow who'd written the thing was a man of few, but also too many, words. Unlike my youthful self, he prioritized fact over feeling, carefully noting every task he tackled. Ninety percent of his waking hours involved mending nets. His language was simple, unvaried . . . as soul-deadening as I expect net mending itself is. My stepfather could not get enough of it and was often moved to read passages aloud to family and visitors.

For a theater-loving teenager, separated from the nearest town by nearly twenty miles (three of them across Lake Superior's frigid waters), this was hell.

Now I get it. This terse fisherman's diary is the book I'd want with me if any of the dystopian narratives I can't get enough of come to pass. His faithfully recorded daily doings could save lives! Think of all the things a net can do—catch fish, boobytrap zombies . . . I used to wish the author had jazzed things up with romance and petty gossip. Now, I appreciate the importance of documenting weather, the comings and goings of wildlife, and steps taken to repair a leaky boat.

2. Creative Strength Training

Improve the endurance, tone, and coordination of your creative muscles by going heavy. Strive for quantity, not quality—just write and write and write. Don't burn your pages. Burn through them! If your reputation is cause for concern, write "Property of [someone else's name]" on the cover. Then spill it, even if there's nothing much to spill. Sit on a park

bench and consider the inner life of squirrels—whatever! You're not panning for gold. You're just panning.

3. Brain Booster

Any neurologist will tell you keeping a diary can't stave off dementia indefinitely, but if you're keen to build up the ole cognitive reserve, keep a daily diary in a weekly or biweekly way. It ain't easy trying to remember what happened a week ago last Tuesday, unless it was your birthday or something. This type of diary is best kept in pencil—erase and revise as more fragments shake themselves into your consciousness.

Sharing Your Diary: A Cautionary Tale

Weigh the ethics before squeezing art from the raw material of your journals in recognizably bloody ways.

Hopefully, your scales will be better calibrated than mine were when I used an Off-off-Broadway puppet show to settle some long-ago scores with the girls who had wounded me in seventh grade. Its text was drawn verbatim from the pink-paged volume into which I had poured my late-seventies heart. Its cover features a non-threatening, Kewpie-haired urchin under the simpering, perfect-for-all-the-wrong-reasons motto *Remembered Joys Are Never Past*.

The diary aspect of this stunt was not a particularly original idea.

Perhaps you've heard of *Mortified*, a popular live event that's spawned a book or two. *Mortified* performers read aloud from their uncensored early diaries before a paying, and usually well-lubricated, audience. It's a close cousin of stand-up comedy, with projected photos and scanned pages providing extra oomph.

The sweet spot for these readings is definitely middle school.

As an audience member, I get my fill of such shenanigans pretty quickly. I can't help but feel bad for the youngsters whose hopes and hurts are laid bare before a bar full of grown-up hyenas. Self-deprecation can be a very attractive quality at the mic, but not when it takes the form of dragging your younger self off the bus and under its wheels.

Interestingly, sacrificing a handful of former twelve- and thirteen-year-olds who did *not* grow up to be me felt entirely justified . . .

I should have inspected this project's foundations for rot more carefully before pitching it as part of a fellowship application I only learned of the day before its deadline. An impulsive grab . . . and I got it!

I'll admit, when your teenage diary is defined by such existentially accurate declarations as "I've lost my popularity completely," it feels mighty good to be picked, even when that triumph is predicated on a whip out.

The other fellowship participants were a good deal younger than me and totally mystified by the binary codes of seventh grade in late-seventies Indiana. I was the more experienced writer (not that it mattered, given the verbatim nature of my text) but light-years behind them in terms of puppetry.

I scraped along as best I could, sewing lumpy rag dolls personalized with iron-on transfers of actual faces culled from actual yearbooks. I equipped my "puppets" with Doritos, tiny cans of Tab, and the real names of my former tormentors.

Seriously, it's a liability just to know me.

Midway through the fellowship, I started having misgivings . . . and not just because I know how hard it is to attract an audience to Off-off-Broadway experimental puppetry over Memorial Day weekend.

It was queasy-making whenever I slowed down enough to imagine how I'd feel were the roles reversed. I lost sleep, stressed that one of the rag dolls's human counterparts would somehow get wind of the show. One of those middle-school meanies has been my friend on social media for years, far longer than our comparatively brief flesh-and-blood friendship. I feel bad that she's so supportive now. I doubt she's liking my posts to atone for all the cruel things she said and did way back when.

Probably she's warmed by memories of good times in each other's company prior to the catastrophe of our pubescence. If there's some misplaced awe that someone she's still in contact with grew up to act, write books, and live in glamorous New York City, I'll take it.

Any equally cruel things I may have said to *her* are apparently forgotten, unless she wrote, preserved, and is in the habit of consulting a seventh-grade diary of her own.

I'm loath to hurt her feelings.

But I also hate to cancel a project once it's been announced, money has been spent, and other small potatoes have invested their time in good faith that the thing will see the light of day. Sunk costs. It happened. To the best of my knowledge, she didn't find out.

But now I'm harboring a secret more stressful than anything I wrote in that journal.

This chapter is not to say don't spill your guts, especially if the poisons you're purging are of a more serious nature than the greasy kids stuff that informed that puppet show (and the course my life would take as an adult).

Just think long and hard before you commit to not changing names.

A Consistent Practice

I draw a three-panel comic strip every day, answering the question, "What did you do today?"

—Ben Snakepit

Ben's diary comic is far more gripping than any celebrity "news." His bite-sized daily entries may seem like no big deal when taken individually. Except that he's amassed tens of thousands of these strips. Soon he'll top a hundred thousand.

They represent an infinite undertaking, a massive work-in-progress, and a commitment that's been kept for over twenty years. That's particularly impressive, considering how many of the early panels depict wild parties, in which our hero, his eyes reduced to Xs, is surrounded by literal party monsters.

Snakepit is a testament to the power of a long-running, highly personal small potato project. Keep doin' it, and it not only becomes important to you, it'll become important to others, as well.

There's no real blueprint, but Ben has shown us how maintaining a consistent style and sticking to a dependable schedule keeps readers invested through various life changes, many of them incremental. His three-panel mandate condemns a lot of his daily life to the cutting room floor. There's a lesson about editing here, but I'm not sure what it is when so much of what does make it in are things we've been conditioned to gloss over:

boring day jobs, home and auto maintenance, watching movies on the couch, playing with the dog, lazy weekends . . .

As a reader, it goes by really fast. You can huff a week or two of Ben's life on the toilet. If you're in search of a new regimen, try rendering your day in three distinct panels, or sentences, or photos.

Do it for a month. It's much harder than it looks. Especially if you intend to offer it up for public consumption.

Sustaining Interest

I blog daily, that's my most regular discipline.
—Trav S.D.

Sometimes your area of expertise helps predetermine your produce-aisle size.

Context plays a part, too. Trav's deep knowledge of vaudeville, circus, and theater history would have made him a very big banana back in the nineteenth and early twentieth centuries, a heyday much like 2002-2004 was for blogs.

Now fickle favor has shifted to makeup tutorials, TikTok recipes, and cat memes, yet Trav soldiers on, freely sharing tantalizing daily bits of lore and biography:

- "Katie Sandwina: Strongwoman of the Circus"

- "Winchell Smith: A Lamb Who Didn't Get Lost"

- "Mademoiselle Ella Zoyara: Drag on Horseback"

A century from now, when we have followed the tap dancing Baron Twins, animal impressionist Alfred Latell, and Thelma Hill: The Mah Jongg Bathing Girl, to the grave, who will muster such a sustaining interest in the Ghost of Creative Arts Past?

My money's on a small potato. We seem to have a knack for getting really worked up about stuff that leaves the bulk of the populace cold. Given all the hit movie adaptations featuring magic portals in drafty old houses and the backs of wardrobes, I'd expect more folks to be keenly delving into the anachronistic . . . oh well, more for us, I guess.

Funny to think there was a time, not so long ago, when basically *nobody* was into Alexander Hamilton. Now he's up there with Prince and David Bowie, leaving Winchell Smith and Thelma Hill to languish in utter obscurity, if not for the efforts of Trav and the passion he pours into every blog post.

Hail to all the small potatoes who get hung up on the work of other potatoes that history has cut down to size! Hail to those whose interests are not bound by prevailing tastes!

Bask daily in a subject that brings you pleasure. Study it. Leverage whatever tools are within reach to present your knowledge to a possibly disinterested wider audience.

Be your subject's Vestal Virgin. Others can't find their way to your temple if you don't build and maintain it. Your temple need not take the form of a blog. It could be a collection of essays, comics, or poetry. A bunch of songs, short films, or animations. A series of paintings or performances. Keep that flame lit.

Bribe Yourself for a Good Cause

Committing to a daily creative practice is no guarantee you'll greet your leash with the dumb joy of a dalmatian for whom every walk is the BEST WALK EVER!

Some days the sap's slow to flow.

Excuse a porn set analogy, but you've got to be your own fluffer every now and then. Learn which tricks and tickles will revive your flaccid resolve, and don't be shy about using them.

> I like having headphones or music and candles or incense and mood lighting. I like having my windows open, climate-permitting or not. And I always have three or four tarot decks and a bunch of reference books and all my supplies within grabbing range.
> —Anonymous Zinester No. 2

> I am unable to work until I have a pot of tea before me.
> —MariNaomi

> I regularly and frequently eat dark chocolate. I don't have to practice that because I'm so good at it.
> —Winter Miller

There are, of course, raunchier pleasures, and if those are what get you to pick up your paintbrush or pull on your unitard, close the door and have at it!

Traditionally, fluffing is used as preparation, but away from the porn set, you may find it works better if you withhold it 'til the deed's been done.

You know your work habits better than we do. What's going to persuade your lips to spend forty-five minutes on your French horn? Pleasure first or pleasure after?

I know writers who swear by an app that shows them a picture of a kitten every time they hit their predetermined word count goal.

Think about some ways your internal fluffer could stimulate you into getting the job done, and write them down for future use.

Creatures of Habit

Creatures of Habit require very little fluffing beyond unobstructed access to their habits.

Having identified a winning formula, they've arranged their lives around implementing it. They thrive on stability and know it.

My daily routine is: exercise in the morning, eat lunch/run errands, then work on comics from 2:00 p.m. onward.
—MariNaomi

I try to write in the morning in the two-to-three-hour clarity zone after my first cup of coffee, but it's a struggle. It involves two to four half-hour timed writing exercises with five-to-ten-minute breaks between each one. Sometimes I do freewriting, blanking out my computer screen so I can't see (and therefore, judge or try to edit) what I've just written. Some days are all about judging and editing. Usually it's a combination of both.
—Greg Kotis, 55, Playwright

I'm pretty much a person of habit. The first half of my day ideally goes like write > emails > write > Patreon stuff > write > emails > write on future projects

> lunch > record shows > exercise > post-production stuff > emails > at some point my energy and focus drop off. I do not do well when my routine is thrown off as I tend to panic and feel shame for not being normal.

—Drew Ackerman

I have daily exercise and meditative butoh practices. From there I might work on drawing, painting, writing, music, video stuff, or I might read all day or watch stuff with my husband, Eric. Last night we watched a documentary about the Cockettes.

—J. Gonzalez-Blitz

Good habits are ones that work for you—and don't make you neurotic about knocking off for a good Cockettes doc every now and again.

They can take some getting used to if you're not a natural-born creature of habit. You may need to bind yourself to the mast for a bitsy.

Set up a standing parallel playdate with a fellow small potato for extra accountability, someone who understands the purpose of the arrangement and is willing to redirect and be redirected whenever one of you veers off course.

After a while—boom! You've created a habit. You are a creature! Congratulations!

That may not be the end of the fairy tale, however. Good habits can go bad. What happens when your extremely regular, longtime habit (or long-running project, for that matter) starts feeling like one of those wooden ox yokes from *Little House on the Prairie* times? You could force yourself to keep pulling . . . or, you could opt to ride in the fucking wagon.

We recommend playing hookie from your habit for a day or two, then come back ready to reassess. Perhaps a bit of a break was all you needed, and your yoke now feels as light as a puffy pink cloud.

That's the best case scenario. Most of us will experience a bit more straining and snorting. That's okay, as long as there's also some motion, some tilling of the soil.

If however, you stand around all surly, refusing to budge, that habit has turned to stone. Wriggle out from under it, and leave it on the road.

Look for a new habit, or just run free for a while.

I used Instagram as a regular practice to make weekly animations, but now see that's not a good strategy. I put so much time into little videos, which could be put into a greater project.
—Maria Camia

Good habits gone bad can:

- Stand in the way of activities or avenues you might enjoy exploring.

- Nail you to a place, job, role, or body you no longer wish to inhabit.

- Drain your bank account.

- Whisper that it's not their fault you greet each new day with a colossal hangover and low self-esteem.

If your habits are demon-shaped, they are not fueling your work, no matter what they whisper in your ear. Do whatever it takes to exorcise them. Call that 1-800 number. Show up to that meeting. The thing that makes you funny or raw or unlike anyone else does not come in a bottle, pipe, or powder, and will not desert you if you get clean.

Find good habits by sampling what works for other small potatoes then: Customize. Calibrate. Recalibrate.

Or conclude that you're an entirely different sort of creature than the ones who thrive on habit.

Creative Bingers

It used to be bingeing implied bad skin, ruined teeth, and a secret stash of Hostess snack cakes.

Now the primary association has shifted. Guzzling an entire season's worth of quality programming in the course of a single weekend is now the most universal definition.

But we're going to consider bingeing as it relates to small potatoes whose vivid creative life spurts forth without the scaffolding of a set routine.

For a long time, I bemoaned my lack of a regular practice and tried to work it into my life in very heavy-handed ways. I once developed a daily art worksheet to fill out in order to convince myself I was practicing every day . . .
—Emmy Bean

What I love about a binge is the creative force it taps. If we're lucky, it keeps gushing all the way to the project's completion.

As with the labor that terminates in the delivery of a human baby, it's normal for bingers to feel completely wrung out when the binge subsides.

I tend to just plunge in obsessively until I exhaust myself then take a long break staring dead-eyed on the bed.

—Sabrina Chap, 42, Musician, Writer, Performer

If you feel a binge coming on:

- Lay in supplies, including food requiring minimal, if any, preparation.

- Clear the calendar.

- Put your social media on lockdown.

- Give those you live with fair warning.

- Stay hydrated.

Collaboration

Whether bingers or creatures of habit, most small potatoes find themselves collaborating at some point. There are some whose work is almost exclusively collaborative.

When collaborating, it's important to get things onto a calendar, preferably a communal one, so you can anticipate and adjust.

There will be times when the common good requires creatures of habit to relax boundaries and alter routines.

There will be times when the common good requires bingers to commit to blueprints and deadlines before the spirit has moved them.

Collaboration is compromise. Flexibility is crucial when attempting to meld multiple visions and approaches into an equitable, cohesive whole.

Once I am in tech, I can go fully into my brain and sort out how to fix things, but the making really relies on collaboration and learning how to work with each of the actors in a process.

—Meghan Finn

Sometimes you get to choose your collaborators. Sometimes you don't. Sometimes you do, only to discover you chose wrong.

My dream collaborator:

- Arrives prepared and on time.

- Shows up fed, caffeinated, and well-rested, or if not, fakes it cheerfully. Doesn't need to look at their fuckin' phone every two seconds.

- Treats interns and other less-experienced collaborators as respected members of the creative team.

- Refrains from complaining about things we cannot change.

- Admits wrongdoing and moves on, rather than copping to bullshit excuses.

- Shows a robust appreciation for others' contributions.

- Says goodbye on the way out and hello on the way in.

- Speaks highly of the project to others even after the collaboration has ended.

- Responds to emails in a timely manner. Confirms every time confirmation is requested.

- Brings cookies from time to time.

Have I always been that collaborator? NO! More on that later . . .

Deadlines

I am totally erratic. One thing I do know is I am more likely to complete something if I am given a deadline.

—Liz Mason

I also relish a deadline. Somehow they always seemed easier to meet when my time was ruled by the constant needs of small children. Now that I've got more choice about when, where, and how the work gets done, I tend to fritter away any head start I may have had, bumping up against, and even blowing, those deadlines (as the very patient publisher of this book can attest.).

I just work on whatever deadline is looming. I'm not great at multitasking!

—J.T. Yost

(Says the father of two young children who runs a comics distro and publishing empire out of his New York City apartment, while also making his own comics and peddling pet portraits on the side . . .)

My days are pretty unstructured. I'm not a very disciplined person, but I have a lot of accountability: rehearsals, deadlines, collaborators I've committed to. I'm just relentless in my drive to do things and finish them and do them well.

—Ellia Bisker

The surest way for me to be productive is to have a deadline—a production, a workshop, a submission, or even just a friend who's waiting to read something I've written. Once I have a deadline, I'm usually pretty good about working.

—Greg Kotis

Deadlines are exoskeletons, giving form to our work even when it's mostly just goo. I love to tell people that I'm on deadline. It makes me sound so viable and allows me to tender my regrets to invitations I'd feel hypocritical about declining under other circumstances.

Not every small potato is privy to a steady flow of deadlines, but you can rustle up a reasonable facsimile by signing up to participate in Inktober, National Novel Writing Month, 31 Plays in 31 Days, etc. These sorts of challenges proliferate on the Internet. Brace yourself to be deluged with hashtags, friend requests, and content. Daily progress updates come with the territory. My pattern any time I join one of those highly public online challenges is to start strong, accidentally skip the third or fourth day, then spend the next week actively resenting the showboats with big word counts, beautiful full-color renderings, and (I'm guessing here) flat bellies and immaculate living quarters.

After that, I'm a ghost!

Don't rule yourself out just because your knees go weak at the thought of all this accountability. That just means you're the perfect candidate for our

Small Potato HypoAllergenic DIY Deadline Challenge PAT. NOT PEND

This challenge builds on my love of the public domain, which includes pretty much every book published in this country prior to 1926. (By the time you read this, more years' goodies may have joined the list, so do some snooping.)

Public domain titles are free for the picking. No need to worry about copyright infringement, unpaid royalties, or intellectual property theft. It checks so many of my boxes—recycling, thrifting, a sentimental fascination with the long dead . . .

Here's how to participate:

- Hit a library sale, a secondhand shop, or an elderly relative's dusty shelves for a book published in or before 1926. (Extra points if you have zero interest in its subject.)

- Decide how many days your challenge will be.

- Lift that number of sentences from the book. Dealer's choice as to whether you make deliberate selections or go with blind picks. Better yet, hand the book off to someone else and let them choose the sentences you'll be working with. This is particularly advisable for those who tend to cheat at improv and pin the tail on the donkey. The challenge works best when the sentences control you, not the other way around.

- Cut out or copy the selected sentences and deposit them in your unused mop bucket. (Mopping should always take a back seat to art!)

- Sound the starting pistol, reach in your bucket, and pull out a random scrap.

- Every day up to and including the date you've settled on as your finish line, grab a scrap and make something inspired by whatever's written on it.

Work in the medium in which you feel most dextrous, venture away from your comfort zone, or go Leonardo and do a bit of everything.

For best results, aim for entries of manageable size—songs, poems, drawings, collages, and flash fiction over operas, eddas, altarpieces, and Great American Novels.

Small Potato Hypo Allergenic DIY Deadline Challenge

CERTIFICATE
of Completion ~
& Achievement

IS PROUDLY PRESENTED TO

On _____ 20____

DATE

by Her Royal Heinie

Ayun Halliday

Queen of the Apes

Try to tackle the challenge early in the day—whatever that means to you. Ideally, the daily challenge will be something you look forward to doing, rather than another unaccomplished task to castigate yourself over come bedtime. On the last day, you'll have the satisfaction of having stuck with something and a quantifiable output that's yours to keep, without the added stress of seeing how anyone else approached the challenge. No hashtags. No comparisons. No need to confine yourself, consciously or not, to the sort of work that goes over well on social media.

Lucky you if you accidentally create something that can be published, recorded, exhibited, or performed publicly . . . don't sweat it if you didn't. You're probably sitting on the beginnings of . . . something.

Above all, you you will have earned the certificate on the previous page, suitable for enlarging, embellishing, and hanging in your local dumpster's gaudiest frame.

Meditation

I have a set meditation practice in the morning and before bed.
—Maria Camia

Not everyone feels comfortable meditating in the traditional sense. I get more from spontaneous naps during yoga class. I have tried to meditate inside my apartment, but there's a lot of competition from unfolded laundry, the insurance issue I should have dealt with last month, the litter box, the top volume political discussion taking place on the other side of the wall.

Like most humans, I dislike waiting, especially with no ready reading material. Traditional mediation can seem like waiting, but I've discovered that actual waiting is the perfect time for me to meditate. It absolves me of my need to be an active player in the

grand equation of life. And it has a built-in end time, even at the DMV. Eventually, I will get to the front of the line. That signals a return to the conscious world as clearly as any Tibetan singing bowl.

Oxygen flows in and out my nostrils wherever I am—the bank branch, the subway platform, the post office. Meditation gets even more interesting in the Great Outdoors, especially here in the city. There's a greater element of surprise, more life forms to fall in love with.

Bustling insects, leaves in near constant motion, swaggering teenagers, furious one-sided cell phone conversations, colors of passing umbrellas, rotting jack-o'-lanterns, clouds, window displays, dandelions, abandoned bananas on green park benches, swirling plastic bags . . . these things which usually mean nothing to me can mean everything to me in what passes for a meditative state. They push my reset button. In through the nose, out through the mouth. Ignore the concerned kiddie, tugging at their mother's sleeve: *Mommy, is that person okay?*

Yes, child. Move along. Nothing to see here but universal vibrations.

Do it every day, or reserve for first aid, like when you're gonna start bleeding out of every pore if you don't escape your home, your studio, or the project that's causing you so much tsuris.

I personally don't feel the need for a mantra. Mantras always make me feel like a bit of an imposter. I'm happy just to relinquish control of my facial expression for a few minutes, to focus on my nostrils and lungs.

If you need a mantra, you could always try pulling a word or two from our growing manifesto.

Social Media vs. Productivity

PANIC SCROLLING/SPITE SCROLLING/DOOM SCROLLING . . . KILLING MY VIBE. I need to force myself away from social media cuz it seriously gives me brain rot.

—Anonymous Zinester No. 1

On to the inverse of meditation.

There's a ton of non social media devoted to social media's deleterious effects on our mental health, the dragons it has put back on our map.

Social media's terrain is vast. It's rife with potential for getting the word out, connecting with fellow travelers, getting wind of opportunities, and keeping skin in the game, but those dragons are real.

Social media is not representative of reality. You need to hold that with you when you are working with it. You are getting the best and worst of people shouting into a void. If you give it too much power, it can waste your energy. I am selective in how I post about my personal life, but I also try to communicate where my heart is at on specific issues pertaining to art and life. If I use things I see or read on social media as a launch for an idea and then walk away from social media, social media can be helpful.

—Meghan Finn

I am obsessed with other people's success. It's something I love to observe and compare myself against. I'm not convinced that it's a completely destructive or useless practice. Instagram does this for me in a big way. Facebook used to until I put myself on a ten-minute timer every day. Now I only get a little glimpse of that deep, dark rabbit hole.

—Emmy Bean

I find social media helpful in that I use it to keep track of what I am doing, almost like a personal arts blog that shows snapshots of what I have been doing. As someone who is constantly putting random things on my head and calling it a look, doing upwards of ten costume changes every show, it's nice to have this visual lookbook of things I have put together, so I can remember what to try wearing again or what to avoid. I don't think I have made the move to having an audience or fans on social media. I interact with my friends. There are like maybe ten people who I would say started in the audience/fan dynamic, but we chitchat back and forth and have become friends through it. I honestly care about their lives.

—Shelton Lindsay

I play two Facebook Live concerts every week, then post them on YouTube and my website. It's detrimental because the promotion and maintenance of my online presence takes up precious time that should be spent creating "content." But it's helpful because I'm forced to put something together every week and have some robust live interaction with all the folks who show up. I recommend using pictures, humor, and pith! I'm sure I need more pointers than I can offer . . .

—Nick Balaban

You want pointers? Okay, here's one: saddle those dragons. Ride them. Do not let them ride you. Make them do your bidding. If you are on fire, someone needs to be sealed up in a cave or possibly taken out for good.

(No, not you.)

Just don't wait around for some brave somebody or other to show up and do your smiting for you. That's on you, Princess.

The Small Potato System

Gotcha!

There's no Small Potato System.

> I often think that someone else's practice will suit me; that what I need is a program for success, an outline, or a plan. Since having a kid, this idea has thankfully gone out the window. There are helpful ideas and structures out there, books and stuff about being an artist and having a family and keeping your shit together, but I try not to take it to heart the way I once did.
> —Emmy Bean

Roger that. I estimate I'm about 80 percent immune to all the articles, TED Talks, and targeted social media ads promising to unlock my limitless potential if only I cleave to their system.

The problem occurs in the wee hours, when the vulnerable 20 percent of me succumbs to the anxiety that is secondary insomnia's frequent escort. Did you know there are almost as many systems for conquering insomnia as for tapping your creative powers? None have ever worked for me, including the ones that would have me power down my devices and lock them in a drawer, prior to retiring. Two in the morning, I get up, pee, drink some water, and before I know it, I'm having a scroll . . .

Insomnia brain ropes me into watching videos and entering my email address, even as I fret that I'll never remember the acronym that's the central pillar of the system, the only lifeboat that can save me, the one secret all successful people know, the habit I should have gotten into years ago, the transformative power that's available to anyone willing to shell out for whatever's behind the paywall of that free introductory lesson . . .

Mercifully, each new sunrise clears away the cobwebs of nocturnal delusion. I know myself well enough to know I will *never* cleave to anyone else's system. Systems remind me of temping in soulless, glass office complexes. Down with systems.

Up with manifestos!

Motivation

"What's my motivation?"

That's actor shorthand for "I'm an insufferable, self-regarding hack." I presume most of us know better than to utter such a question in the rehearsal room, but as small potatoes, it's healthy to plumb our motivation, figure out what's keeping us in the game even when the rewards feel few and far between.

Maybe a better question is, "How do I make this thing go?" Imagine you're strapped into Disney's *Dumbo* ride: "How do I make this thing go?!" Ask like a child (or a Martian visiting earth for the first time).

All the other Dumbos are rising up into the air, so yours must have that capacity, too. But how? What do you have to do? Push its hat? Pull the bar? Flail? Scream?

If you can find your motivation, you can make the thing go.

Personally, I am motivated by the nagging sensation that the ride will be over long before I get the hang of flying my elephant.

I am motivated by fear, trying not to live in fear. Do the hard stuff first.
—Drew Ackerman

I am motivated by ego, drugs, fear of being basic, and the desire to impress friends.
　　—Bob Laine

I am motivated by the specter of having to find a real job.
　　—Steven Svymbersky

I stay motivated by bodybuilding.

—Akin Salawu

I have OCD that manifests itself as an in cessant compulsion to perform.

—Stephanie Summerville

I stay motivated by realizing that there are always stories to be told.

—Mimi Pond, 63, Cartoonist

To stay motivated, I take time for myself—lots of sleep, meditation, exercise, and hanging with coworkers or friends. I watch fun YouTube videos about extraterrestrials. I listen to podcasts by the Asian American community or artists. It makes me want to work on my stuff at other times of the day.

—Maria Camia

Some days I don't stay motivated and my thoughts are very scrambled. I'm usually able to maintain with medication, maintenance therapy, and lists to remember to do things. But sometimes I get overwhelmed.

—J. Gonzalez-Blitz

This is just the way I am. I've been a workaholic/type A personality literally my entire life, and it probably has something to do with the early onset bipolar disorder. I don't have any handy quotable tips or tricks. Everybody is wired differently, and it's just the way I'm wired.

—Anonymous Zinester No. 1

I am mainly motivated by being in touch with my mortality. That's the big one, the deadline. A big part of it feels like flossing/brushing—if I don't do it, I feel weird and bad, so . . .

—Nick Balaban

THE SMALL POTATO MANIFESTO

WE RELISH THE FREEDOM OF OUR RELATIVE SMALLNESS WITHOUT HOPE OF WEALTH. THE ONLY TIME WE GET IT WRONG IS WHEN WE AVOID DOIN' IT.

④ GET 'ER DONE

Finish That Thing

As every Hoosier knows, the checkered flag gets waved when the winning driver completes their final lap of the Indy 500's two-and-a-half-mile oval course.

I'm too claustrophobic to imagine how I'd behave, wedged inside one of those incredibly noisy, wheeled coffins for two hundred laps, except that I'm fairly certain I'd lose count after the first few times around, when the scenery becomes as repetitive as the background of an Augie Doggie cartoon. I'd need the checkered flag to tell me it was over.

This is a problem few small potatoes have. Whatever project we may be working on, most of us have a very clear idea of what constitutes finishing. Ditto on what constitutes leaving something unfinished. Flip open your laptop and check the date the file containing the play or novel you started a few years back was last opened.

Artists, your unfinished project may be propped facing the wall, literally gathering dust.

Musicians, remember that banjo you acquired the summer before last? Its strings are humming "Honey, Don't You Love Me Anymore?"

Why is finishing so hard?

You know why. Because we're human, and as such, we don't get to be good at everything. The things we're bad at can be even more predictive than the things at which we excel. Like, I'm bad at driving and maintaining my composure in tight spaces, ergo, I'm never going to qualify for the Indy 500. What, you were hoping this chapter would contain some helpful tips for making it across the finish line? Okay. How about this? Get good at some of the things our contributors say they're bad at:

Time management, organization, follow through.
—Nick Balaban

Meeting deadlines, staying on course.
—Moe Bowstern, 53, Writer, Performer

Not doing the hard thing first.
—Maria Camia

Creating good habits and sticking to them. Going to bed at a reasonable hour. Waking up early. Showing up on time. Basically everything related to discipline and self-control.
—Ellia Bisker

I could listen more and talk less.
—Mimi Pond

Feeling okay with taking an evening to breathe when there's so much to get done.
—Anonymous Zinester No. 1

I wish I was better at saying no and not feeling bad about doing so.

—MariNaomi

I could speak up faster when shit goes wrong. I could take more time to do my own work. I could slow down more. I could believe in myself a ton more.

—Emmy Bean

Don't forget that the responsibilities of being a parent or caring for an aging parent can also cause the race car's wheels to come off long before the final lap. How are you going to do the opposite of that? Leave your baby and your frail, confused mother on the side of the road and hope for the best?

Literary Spud Maximus Neil Gaiman has a much circulated quote, about the importance of finishing what you start:

Whatever it takes to finish things, finish. You will learn more from a glorious failure than you ever will from something you never finished.

The Internet goes cuckoo for that quote. I'm of two minds about it.

I love how it leaves no room for bullshit . . . and also hate how it leaves no room for bullshit.

The man has a personal assistant, truckloads of money, and at least one dedicated space in which to work. He's at a pretty lofty remove from the sort of daily trials that plague those of us reading that quote.

When you're a small potato, just getting from place to place can be a challenge. Same when it comes to getting nutritious food on the table at the appointed hour. I know, I know, Neil Gaiman has challenges, too, same as anybody, but I'm fairly confident his don't include his personal laundry.

MY DAD USED TO TELL ME IT DOESN'T MATTER WHAT KIND OF GARBAGE YOU'RE PUTTING OUT CONTENT-WISE, AS LONG AS IT'S THE ABSOLUTE BEST IT COULD BE PRODUCTION-WISE.

DOT YOUR i's. CROSS YOUR T's. MAKE IT THE BEST LOOKING GARBAGE ANYONE'S EVER SEEN.

ANONYMOUS ZINESTER 1

A creation is never truly done. It just has to be done enough. Understand that you will never be truly satisfied. Also, there will always be a typo after it is printed. Find it. Resolve to correct it in the next print run. If there is another print run. Then move on. Finished is better than perfect.

—Liz Mason

Create Accountability

I tell my friends about projects I'm working on.

—Anonymous Zinester No. 2

There's a highly effective way to get yourself to finish or, alternatively, start a project.

Tell someone about it.

They probably won't notice or care if you peter out, but you can pretend that they will.

There's an off chance you'll tell a tenacious soul who will not only remember but inquire how it's coming along every time you run into each other. The only way to get 'em off your back is to do your thing!

I've become mistrustful of openly expressing goals because I've had frenemies backstab and throw me under a bus in the past. I don't think you would do that, but hey! I don't know who's gonna pick up this book, right?

—J. Gonzalez Blitz

Well, yes and no. I'm pretty sure anyone picking up this book is a top-notch human with flawless scruples. On the other hand, prudence is not paranoia. Be mindful of vultures. Don't share blueprints, especially when everything's set in jelly.

However you feel about intellectual property rights, creative commons, and the zeitgeist, it's treachery of the highest order when someone swipes your larval baby out from under you and parades it in a pram, gussied up in ridiculous amounts of lace and bows.

Work hard, and limit your remarks.

It's not just prudent, it's polite.

Believe it or not, your host's boyfriend's visiting sibling isn't all *that* curious about what you're working on. They were just making conversation in the bathroom line at the party.

I once told a fellow backpacker that I planned to enroll in the Chicago School of Massage Therapy upon my return from Southeast Asia. Mind you, I had no idea what the requirements were or how much tuition might be. I just liked the idea of incense, bamboo flutes, and transitioning out of restaurant work. My fellow backpacker was very receptive, having gone through a "maybe I should go to massage school" phase herself. Her due diligence was a lot better than mine. She'd purchased a book on the subject, and since she no longer needed it, she offered to mail it to me upon her return to San Francisco. That was it. We hung out for forty-eight hours, then we went our separate ways. I met more travelers and told them about my plans for massage school. Eventually, I made it back to Chicago, where that goddamn book was waiting, like a promissory note was coming due.

This was long before the advent of social media or even email. I sent a thank you to the address she'd written in the back of my journal, but apparently she'd moved. By the time my letter was returned to me, it was too late! I had already enrolled in massage school.

> I say yes to projects I want to do, and then I have to do them—because I have already made the commitment. This motivates me.
> —Meghan Finn

> I allow myself to call it quits on projects that aren't working out, and know that I can pick them up again later when it feels urgent.
> —Anonymous Zinester No. 2

Oh Look! An Escape Hatch!

There are no memes celebrating bailing on yourself, because the Internet loves Neil Gaiman more than it loves you, and Neil wants you to finish all the things. But bailing on yourself can wind up being very productive, provided you go about it in the right way.

If a project isn't working, don't dump it behind a reinforced steel door and deprive it of food 'til it no longer calls out. Do you want it to haunt you?

Be a grown-up and call it quits officially.

Don't worry about your host's boyfriend's visiting sibling, or whoever you may have pledged yourself to in a bid for the finish line. As I said, they probably won't care . . . or remember. As long as you have no collaborators, bailing is entirely your call. And beware false friends who argue strongly that you should (or should not) bail on a project you're unsure about. Whatever they've got in mind, it's likely not your best interest.

Barring some natural disaster or a cluster of cancer cells, *you're* the only one who gets to decide whether or not to see a project through.

Bail because *you* want to, because life's too short, because every fiber in your small potato heart yearns to get cracking on a different idea that's been eating at you in a good way.

Bail so you can circle around to something you bailed on long ago.

Just don't build a bonfire. A closet, drawer, or external hard drive will suffice.

When to Lock the Escape Hatch

The times when I've needed to stay motivated are when I'm working with others on someone else's idea, and they don't have their shite together. To stay motivated in these cases, I remind myself that I made a commitment, and that this too shall pass.

—Lorijo Manley

Bailing can feel mighty tempting when you're up to your eyeballs in someone else's passion project. A project that once sounded like a great idea to get involved with, but now, for whatever reason, seems anything but. Resist! Even if—controversial statement—their project is shitty.

Why?

Because there will be times when *you* are depending on the labor of others to bring *your* shitty project to fruition.

If you can tell the absolute truth as to why you are bailing—for example, when a commitment that was slated to end in April is dragging on through November—you

are free to bail. Bail with as much advance notice as possible. Bail with the understanding that the person you're bailing on may not be too thrilled with your decision. Bail nobly, and don't talk shit about the project you've bailed on.

To the left is a semi-hypothetical example of a time when sticking it out would be preferable to revealing the truth.

The only honorable way out of a situation like that is to honor your commitment. It'll cause some discomfort in the short term, but then you'll be free. Lies burden their author more heavily with every passing year. Don't believe me? Reread Guy de Maupassant's horrifying short story *The Necklace*.

Also? I'm sorry, Julie.

That was a shit thing for me to do.

Don't Commit 'Til You Know the Deal

I hire from within, unless the person is highly recommended by someone I trust. What's on a resume isn't always the person you meet.
—Winter Miller

Last millennium, I got myself into a sticky situation when, young and even more eager to please than I am now, I committed to doing something for an egomaniac who asked a lot and was never satisfied with what they got. A dick, if you will.

Much as I would like to paint myself the innocent victim here, there's no getting around the fact that I behaved badly, not least because I did what I just counseled you never to do. I bailed with very little notice because I could not stomach the thought of sticking around. I was making a hash of what I'd been engaged to do. They hated

everything I brought them. I cringed and swore I would fix it. Instead, I made it worse. I was running myself ragged on every point of the compass. My only relief was the laughter that greeted me whenever I imitated the big banana and some of her high maintenance second bananas for appreciative friends. My struggles were a constant source of hilarity to them.

I can now admit it was a mess of my own making. During our initial interview, the wildly self-regarding top banana asked if I was truly capable of spinning straw into gold for the tiny budget she had set aside for costumes. I said yes, of course.

The correct answer was no. I was incapable of turning my renderings into reality for a budget of any size.

I'd wanted the gig because I was young and inexperienced. Yes, every fantasy I'd been harboring about what it would be like to work with an established company, not as a peon but as a designer, disintegrated within the first five minutes of that interview, but I fooled myself into thinking I could make it work. I *knew* how that experience would pan out, and yet, I accepted the gig. I was like a passenger who has a premonition that the plane's going to crash, but decides to brush it off, not wanting to cause waves by insisting on deplaning after the hatch has been sealed. I blew my chance, with disastrous consequences!

Why wasn't I fired? They would have been well within their rights—I was making a hash of their project. Canning a hapless young person seems like it would be a cinch for those with no compunction against fostering a negative work environment. I can only surmise it's because I was the only sucker to have applied.

But this is a tale of two dicks. I'm the one who fucked up someone else's project, then ran away so as not to deal with the mess. Don't be a dick. Trust your instincts, and do some research before you commit to sharing a bed with someone you don't know.

It's Okay to Fail!

One of the best parts about being a small potato is the freedom to fail. Low stakes! Realistic expectations.

—Anonymous Writer-Performer

I can make mistakes and try things without disappointing the fans that I would if I were more in the public eye.

—Anonymous Funnyperson, 38, Comedic Actor, Improvisor, and Podcaster

Pity the movie star who has the temerity to think she can write a novel. The rock god who fancies himself a painter. Critics have their knives out, and so does the public. How *dare* these public figures wander from their lane to attempt something no one was asking them to . . . how *dare* they do it badly?

Yes! Failing *is* one of the best parts! You can fail *all* the time. The Eugene O'Neill Theater Center's motto is "Risk, Fail, Risk Again." I love this! Being a small potato and taking big risks and failing really terribly is a blessing. You can fail *all* the time. I'm talking standing-on-stage-yelling-"Beep-Boop!"-while-pouring-pig's-blood-over-yourself-for-two-hours failing. You can live out your oddest creative ideas and most people won't see them, hear about them, or know about them. There is something very freeing in that.

—Christine Schisano

Our most colossal small potato failures rarely make a lasting impression on the miniscule sector of the public who squandered a tiny portion of their time or money on us.

Moldy Old Goals

I am likely to be on my deathbed trying to forgive myself for not having gotten to everything I wanted to.
—Liz Mason

This, despite umpteen elders using their last gasps to tell us how compassion and satisfaction in simple daily pleasures are what ultimately matter! Such wisdom is difficult to ingest when we're in the middle of our lives. When the beginning feels closer than the end? Almost impossible.

When I have an idea, I usually try to see it through to fulfillment. If I'm unable to at a particular time, I'll store it away for later when I have time or downsize it to make it attainable. I hope to not leave any work undone by the time I die.
—Anonymous Funnyperson

What goals am I unlikely to achieve? None. I cannot convince myself that it can't be done. I swear, I'm going to Moby-Dick myself in pursuit of Broadway.
—Stephanie Summerville

Fair enough.

I suppose I originally fancied being famous and sought after. I am completely at peace with this not happening.
—Karen Christopher

Me too, for the most part. I'll die never having accepted the Tony Award for Best Actress in a Play wearing the skimpy gown my teenage self admired in a Virginia Slims ad. (Or any other garment for that matter.)

So much for those inspirational posters in elementary school and the children's library. Turns out I can't achieve everything I set my mind to! I can, however, move the goal posts, or dismantle them for reuse in a project unrelated to competitive sports.

I will not be a world-renowned star of stage and screen. Totally fine with that, but I suspect if I'd been even just a little ambitious, I could have at least made my living as an actor.
—Anonymous Writer-Performer

I am unlikely to have a flashy big publisher book out. I had this opportunity once for a lot of money, and I blew it. I've had to make peace with that.
—Rachel Kramer Bussel

I am unlikely to become a hotshot Hollywood screenwriter.
—Akin Salawu

I am unlikely to win an Oscar for production design.
—Shelton Lindsay

I've had different goals throughout my career, and many life goals, which over time proved themselves tedious and uninteresting. So even though I never had, say, a TV series as I once-upon-a-time hoped for, I'm not sure I'd want one at this point. So short answer, there's nothing now that I'm unlikely to achieve, and yes, I am at peace with that!
—MariNaomi

Realistically, me performing on Broadway might not happen. I have to be okay with that and measure my creative success in a different way. When I first started dreaming of performing on Broadway, I had no idea I could write, produce, build puppets, etc. What I have found is that being an actual creator of theater and art is a far more challenging and rewarding path. I can write characters and tell stories I want to see instead of waiting for an audition to come that I am "right" for. I can be experimental or abstract without worrying if the show is commercial. I may get to Broadway, but as a designer, builder, writer, director, or producer. Sometimes you have to give your dreams an oil change so they can take off in the right direction.

—Christine Schisano

I once hoped to run an animal sanctuary, but knowing two friends who ran two different animal rescue organizations showed me that it would eliminate time for just about anything else. I don't think, realistically, that I could prevent myself from creative projects.

—J.T. Yost

I thought I wanted to teach high school English. I went through all the preservice teacher education and by the time I finished student teaching I realized I didn't want to. I made peace with it when I realized that I would not have known that I didn't want to do it had I not gone through all that. And any extra education you have is never bad for you. A lot of the things I learned about teaching I use when I teach zine workshops or just in understanding how people need different modalities when I train people at work.

—Liz Mason

I used to want to make animated films, but now there's such a sameness to them. If I were to experiment with animation it would be a small thing. I wouldn't want to work in it as an industry.

—J. Gonzalez-Blitz

Well, Warped Tour isn't a thing anymore like, as a thing, so that's that. I have made so much peace with that, my dude, lmao. Also, I wanted to open my zine collection to the community, but getting that all organized, much less catalogued, with the living situation and having to continue to participate in straight world capitalism and all that???? Oof, yeah, probs not gonna happen. I should just donate it instead of hauling it around again, but the idea of not having all of it gives me anxiety cuz I'm a knowledge/primary sources hoarder, so . . .

—Anonymous Zinester No. 1

Me being in a famous rock band is unlikely to happen

—Ben Snakepit

I am unlikely to be like anyone else. I'm starting to get comfortable with it.

—Sabrina Chap

EGOT membership.

—Bob Laine

I've already produced the two-part graphic novel which was the project I promised myself I would do before I died, so I'm at peace if there are other goals I'm unlikely to achieve. I still have a large body of work, even if most of it is unrecognized.

—Mimi Pond

All my goals are, were, and will be unlikely to be attained. C'est la guerre.

—Greg Kotis

I never concede such things.

—Trav S.D.

I am at peace, to varying degrees, with everything that has transpired in my life.

—Connie Fu

There's no one path. You can run alongside Trav, swinging your sword 'til the bitter end. Or you can pull the plug on some aged dreams that are languishing on life support. (You can always plug 'em back in, though really, why—when you've freed up space for some late-occurring, previously unforeseen dreams.)

Goals to Hold Onto

Lest you think we've renounced all ambition . . .

I would love to be better at playing the piano. I would love to keep making music with the people I most want to work with, and for that music to be tour-able, and for audiences to hear it and like it. Lately, I've had bigger dreams. I can't shake the impulse to try and become a singer for Cirque du Soleil. It's a pretty improbable career move, but I am stretching into a new idea of what it would be like to test the boundaries of bigness for a moment, and then return, better able to fill a small space.

—Emmy Bean

The ocean's full of white whales. Which would be most fun to chase? Give the matter some thought. Don't fixate on hauling that giant carcass into your boat, because that might never happen.

Consider, instead, the coordinates the pursuit might take you to—some of my happiest travels have been to places I had no particular urge to visit—and who your crew will be. The energetic new friend who flips around the rigging like a monkey, whistling like a bird. The old salt who's secretly pleased to be cajoled out of retirement for one last voyage. A superstitious cook with naughty tattoos and an uncanny knack for predicting the weather.

The whale's just baleen and blubber. A picture in a Greenpeace calendar. A red herring. It's what's happening in the boat that makes the journey so worthwhile.

I'd like to write a book of true short stories from my young adult life.
—Moe Bowstern

I'd like to get a few stage productions of my plays mounted in Manhattan.
—Akin Salawu

I'd like to make more *My Small Diary* and *Not My Small Diary* books, get into more museum shows, and attend more zine conventions.
—Delaine Derry Green

I would like to be at peace with myself and also make one really big sound. Something Stravinsky big.
—Sabrina Chap

I'd like to edit a nonfiction anthology about a topic unrelated to sex. I never want to feel pigeonholed into one topic.
—Rachel Kramer Bussel

I'd like to be profiled in my alumni magazine for my amazing success (so petty!).
—Ellia Bisker

I'd like to write for different media. I hear there's money in them moving pictures. But there I go thinking about the reward, which I'm trying not to do.
　　—Greg Kotis

I'd like to perform and take my art on an international tour. Be the Artistic Director of a theater or production company that gives overlooked artists a platform and support. Get a high five from Oprah.
　　—Christine Schisano

I'd like to visit all fifty states (only four left).
　　—Ben Snakepit

Oh, publish a few books, produce a TV show, find a fun plot of land and make a radical queer commune.
　　—Shelton Lindsay

Move to Kansas, Nebraska, or Iowa with my best friend and support us both on the zine distro. Go on tour.
　　—Anonymous Zinester No. 1

I'd like to become a better accordion player, do more theater, write songs and performances, try to make people laugh so hard they pee their pants.

—Heather Riordan

I'd like to have the bookstore grow and maybe write a book about my experiences in publishing and selling zines.

—Steven Svymbersky

I'd like to publish my body of work as *The Books of the Boble* and play all the great parts for old white men.

—Bob Lainé

A Grammy would be nice. I'm not greedy. Just one would suffice :-)

—Lorijo Manley

I would love to work on a longer form comic (a, *sigh* "graphic novel"). I'd like to be involved in a nonprofit that benefits society in some way.

—J.T. Yost

I would like to make another really big project with Pedro Reyes. I would like to be consistently making work, but more than that, I would like to end immigrant child incarceration in the United States. Be a part of it, at least. Ending that.

—Meghan Finn

I'm only just starting to set goals now, very late blooming. I want to get to the point where I feel super active artistically almost all the time. Materialistically, that probably translates to recording more than ten of my own records and having a full-time working band, as well as getting to explore other creative thingamabobs, including writing, acting, and getting better at playing instruments. If I really feel that I'm unlikely to achieve a goal, I probably have to move the goalpost.

—Nick Balaban

Making spirituality, self-healing, and authenticity mainstream ways of living.

—Maria Camia

To be nicer and less afraid.

—Drew Ackerman

I've always said I wanted to publish a dozen books, but I might be happy just finishing and publishing the ones I'm working on, then calling it a day. I think that'd put me up to . . . nine? I do have a long bucket list of things I'd like to do, awards I'd like to win, folks I'd like to help. But honestly, I feel fine about what I've done so far. No regrets, no dangling dreams. I just want to be happy.

—MariNaomi

THE SMALL POTATO MANIFESTO

WE RELISH THE FREEDOM OF OUR RELATIVE SMALLNESS WITHOUT HOPE OF WEALTH. THE ONLY TIME WE GET IT WRONG IS WHEN WE AVOID DOIN' IT. WE CHOOSE WHEN TO BAIL, AREN'T SCARED TO FAIL & CROSS THE FINISH LINE WITH A MIGHTY YAWP.

❺. LIFE HAPPENS

When Shit Hits Fan

*A*s the global pandemic loomed, I was preoccupied with producing and performing in an Off-off-Broadway world premiere. In addition to worrying about retaining my lines, playing ukulele publicly, and the number of reservations on the books, I had to wash stage blood out of white Tyvek coveralls and check the batteries in a trick necktie before each performance, because I was also the wardrobe mistress, and it was all VERY IMPORTANT!

Until, that is, Friday, March 13, when we small potatoes followed the unprecedented precedent Broadway had set the previous day. Now, virtually every theater in New York was dark, as if a very strategic bomb had vaporized cast, crew, and audience, leaving sets, costumes, props, etc. intact. Everyone with an interest in maintaining public health went home, expecting to burrow in for three unimaginable weeks, that turned into months, then a year . . . Some small potatoes, and a number of increasingly desperate big bananas, found mandatory self-isolation creatively invigorating.

Others mourned the loss of gigs, hotly anticipated retreats, in-person events, and yes, Off-off-Broadway world premieres, but still managed to prove themselves capable of creativity, or at the very least, natural fermentation, concocting tiny, spur-of-the-moment projects that didn't go entirely unnoticed on our old friend, social media, and some cockamamie thing called Zoom.

And then there were those who just barely managed to keep their heads above water. The bobbing fruit harvested by the first, and to a lesser degree, second group made them feel even more like drowning. Even if no one they knew died. Even if they still had jobs or savings enough for food and rent. And you know, the nice thing about it? For a brief period it seemed like we were all in it together. It didn't last, but for a while there, everyone felt like Job, and no one was too busy to hang out the window every night, ringing bells and banging saucepans in a show of solidarity with those who were really duking it out in the trenches. Usually, misery is a bit more isolating.

In the year following my husband's untimely death, my practice fell apart. I'm getting my mojo back now.
—Heather Riordan

Physical therapy and breathing is what I can manage right now.
—Moe Bowstern

If there is a personal catastrophe in your past, you may have reached a point where it feeds into your creative engines. If the catastrophe is more fresh, it's probably busy pouring sugar in your tank and strapping you to a wheel, to ensure you'll be squashed at least once per rotation, once your vehicle's allegedly driveable. Catastrophe will also make you the center of attention for a time, whether or not you want to be. What a shitty time to be treated like a big banana. The vast outpouring of support shown to those who've undergone misfortune is one of social media's nicest dragons. Like Puff. Except he's not all that magic. He can't roll back time, restore that regular little small potato life you used to lead, utterly ignorant of how charmed even the most aggravating parts of it were. What do you say when something like that happens to a fellow small potato?

No one expects you to be alright.

It's okay to take time off. Take as much as you need.

I'm sorry.

It's the pits.

Parenthood

Sometimes, it's exactly as John Lennon sang. The big plan-disrupting thing *is* a baby!

Hardly a catastrophe. In fact, *mazel tov!*

It happened to me. Twice.

I don't regret it for a second. My twenty-four-year-old daughter probes me on the subject every now and then. Does she think I'm holding out on her, that I secretly believe I could have been a big banana had I remained childless?

I don't think that. The world moves too fast for me to totally buy into the gospels of Virginia Woolf, Doris Lessing, and Marina Abramović.

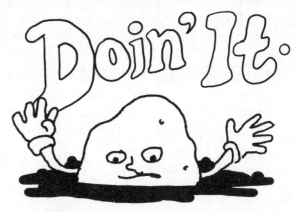

Having kids made it hard, but there were other ways in which they made it easy.

For one thing, there was that glorious decade-and-a-

half when all creative inactivity could be attributed to the temporary tarpit of full-bore motherhood.

Having kids provided me with a fertile subject matter for my zine, my first book, and a handful of paying freelance articles. I also made a puppet show set inside the neonatal intensive care unit where my daughter and I spent her first two weeks of life. The newborns were played by root vegetables because I couldn't figure out how to care for a baby and make puppets at the same time.

We aren't supposed to say this, but being a parent has made me a better artist, one who has increased empathy, better time management, and the ability to let things go. Don't stop working, particularly if you are a woman. You can do both successfully enough.
—Meghan Finn

When everything became "we" instead of "me," my career as an artist began. My plays emerged from fears that parents and adults share. Kids show us how to play, how to care, and how to encounter the world honestly. Having daughters and watching them navigate the troubled waters of growing up was one of the great honors of my life. During their childhoods, I wrote about parents parenting and failing to parent. And I'm still writing about kids. When a young person does something she thinks is impossible, it gets me every time. So I write that again and again. I'm writing a story like that now. The experience of parenting didn't just improve my work, it is my work, and I hope to keep doing it, in one way or another, as long as I live.
—Rob Ackerman

Parenting gives my work a much sharper purpose. It's about offering up what I can as a service for others. My connection to the world has a much more nurturing aspect than it did before I had kids. That said, it doesn't make me any more responsible, nurturing, or purposeful than nonparents—only in relation to who I was before I was a parent.

—Nick Balaban

I take care of my kids half of each day, so I am excited to work on my creative endeavors whenever I am not with them.

—J.T. Yost

Gaining a personal perspective on these most elemental relationships informs everything, including creative work. You realize your parents were crazy for a reason. You become connected to all parents and all children in ways you weren't before having children yourself. You realize the movie *Alien* was really about childbirth. Pace yourself.

—Greg Kotis

If you have just become or are about to become a first-time parent, no matter how you previously conceived of yourself, now is the perfect time to lean into small potato-hood. Be flexible. Be resourceful. The picture isn't ruined when someone colors outside the lines. Don't throw it away. Eventually, you will figure out a way to turn those scribbles into a different kind of drawing. Write one sentence a day. Document your life. Document your kids' meltdowns and skinned knees and less-than-picture-perfect moments, but don't make too big a deal out of your dismay over the career you could be having. That's beyond your control. Document the tub toys.

Now that the kids are teenagers, it affects my creative work less. It gets slightly easier when they turn five.

—Todd Alcott

I am not a parent, but I have a cat. I wrote a whole zine about my cat and then people Venmoed me money to contribute to her vet bills, which was very nice of them. Do not let your cat eat paper. It is definitely not a food for cats.

—Anonymous Zinester No. 1

The World's Indifference

Sometimes I feel quite morose about not being inundated with offers or commissions for projects I'm really excited about doing. I feel morose about not being burdened by a weight of responsibility that would challenge me to live up to a certain kind of promise.

—Karen Christopher

Sometimes you can be chugging along and the rejection and stagnation just gets to be too much. It becomes bleak.

—Christine Schisano

> The hardest thing about being a small potato is feeling invisible, being dismissed by the culture at large, and not having any control over that.
>
> —Mimi Pond

For small potatoes, hustle is not optional.

Unfortunately, there are periods when our self-starter refuses to rise, often when we're between projects, depleted from the completion of an all-consuming project, or a bit bruised by the underwhelming reception it received.

The world's indifference seeps in in ways that are difficult to ignore. Accept that your work will suffer 'til this mood abates. Most of your time will be taken up by self-loathing and resentment, and any work you do manage to crank out during this period is likely to be shit.

(Though maybe not entirely. Could be you swallowed a diamond without realizing it. Don't discard the specimen cups without checking.)

Sometimes, a good night's sleep will put things in perspective. Sometimes it takes a change of season—or scenery—to lift the pall.

It's a hard thing to force.

Gaze at your navel for hours, but don't expect it to have the inside scoop on why the world's so convinced you suck.

Your belly button does not deserve that much credence, and neither does that bitchy, backstabbing world. Just because they're clamoring for your attention doesn't mean you have to give them the satisfaction. Let them think you don't care (though obviously, you do).

Go where the love is. Engage in other activities.

Pull Yourself Out of That Funk

It can be difficult to figure out what to do with yourself down there in the slough of despond. That's why we made you this crib sheet.

Rest

I have been sitting with discouragement a lot in my life, and I am coming to understand it as a signal that I'm actually doing too much and not spending enough time with myself, taking care of my own needs. I watch TV. My friend once told me to write down all the things I had done in the past five years as a cure for discouragement. That really helped.

— Emmy Bean

I nap and get over my ego. Or I remember I'm a boss ass bitch.

—Maria Camia

Spend time in a different sandbox

I go do things that are 100 percent different than whatever art form it is I'm discouraged about making.

—Liz Mason

Take an art break

I get myself out of my head by playing music or reading a book.

—J.T. Yost

I find an inspiring picture book or watch a movie.

—Anonymous Zinester No. 2

Be in your body

Bodybuilding!
>—Akin Salawu

I go on jogs . . . and eat things.
>—Connie Fu

Treat yourself

If I'm ever really sad, I buy myself a Happy Meal.
>—Sabrina Chap

I make Trader Joe's frozen Hatch Chile Mac and Cheese, with a little wine.
>—Emmy Bean

Candy or movie or both.
>—Drew Ackerman

Trust your teacher

My fifth-grade teacher, Ms. Pennington would always say, "If you think you can, you can. If you think you can't, even if you could, you won't." That stuck with me all these years. When I am feeling most down or discouraged it often helps me recalibrate.
>—Christine Schisano

Count your blessings

I really go back to gratitude. There is so much I have that I would have killed for as a young artist. My own theater. A budget. I get to work with the artists I

really love working with. Whenever someone is getting on a ladder for me, I am grateful.

—Meghan Finn

Count your merit badges

I look through old writings or books I've worked on that I'm proud of and try to remember how I felt when I worked on them, especially if I struggled with them. I think, if I got through that, I can get through anything.

—Rachel Kramer Bussel

Get yourself excommunicated

I do priming and incantations, both as a preventative and as a "pump up."

—Stephanie Summerville

Murder and maim!

I remind myself that at the end of the day, none of this stuff actually matters. No one will be killed or injured if I fail.

—Anonymous Writer-Performer

Be a not-so-selfless volunteer

I was hoping no one else would mention volunteering, so I could stake my claim in it. What a goody-goody. Seriously, in addition to being a braggart, I'm practically a saint. One who probably wouldn't continue to show up if there weren't something restorative about being a cog for the common good. I prefer a good long shift of cleaning compost bins or packing pantry donations to contributing my "talents." It's honest, restorative labor, uncomplicated and unpaid.

Keep it legal

Weed.

—Ben Snakepit

Use Others to Pull Yourself Out of That Funk

Misery loves company . . . and the best kind of company is the kind that makes you feel less miserable.

Loan a friend the tools you need

I try to remember I'm indeed hot shit or make a list of all the things I've accomplished, then text it to my best friend who goes "YEAH!!! YEAH!!!!!!!" and gases me back up on my own excellence.

—Anonymous Zinester No. 1

Have a larf

Laughing with people I love lightens the pressure I put on myself to succeed. My friends are a constant source of encouragement and understanding with a splash of sassy "fuck it."

—Christine Schisano

Procreate

I talk to my kids. They always encourage me and lift my spirits.

—Steven Svymbersky

(Note: You needn't procreate to have sex. Have sex here and/or on the previous page if it makes you feel better.)

Give someone else first watch

Eric helps sometimes. Sometimes he just holds me while I sleep it off.
—J. Gonzalez-Blitz

Show up

I go see my artist friends doing great things—that is always encouraging!
—Bob Laine

Take a class

Yay, nobody mentioned this one either. I can claim it! Enroll prophylactically. Learning how to samba or sew or stretch in unaccustomed ways is good, all-purpose medicine.

Complain

I complain a lot! Especially to my husband and to my creative partner, who are both gifted at saying the right encouraging thing.
—Ellia Bisker

THE SMALL POTATO MANIFESTO

WE RELISH THE FREEDOM OF OUR RELATIVE
SMALLNESS WITHOUT HOPE OF WEALTH.
THE ONLY TIME WE GET IT WRONG IS WHEN
WE AVOID DOIN' IT. WE CHOOSE WHEN TO BAIL,
AREN'T SCARED TO FAIL & CROSS THE FINISH
LINE WITH A MIGHTY YAWP. OUR LOINS ARE
GIRDED FOR THE LONG HAUL.

6. YOUR WORK IN THE WORLD

Savoring Small Encouragements

Here's another way to put the world's supposed opinion into perspective:

I think about the good things people have said about my books and comics. John Porcellino of King Cat Comics called *Not My Small Diary* "one of the most important comic-zines in history." And Joe Decie said, "I wouldn't be drawing comics if it weren't for NMSD, it was my gateway drug."

—Delaine Derry Green

What's the nicest thing anyone's ever said about you and *your* work?

Bet you didn't draw a blank.

Odds are you remember the nastiest thing, too, especially if it was said in print or behind your back, but let's put that one to the side for now (or forever).

Instead, let's concentrate on the good stuff. Something my friend Bill (who successfully auditioned for my old theater company in a headless gorilla suit, freshly plucked from the trash) refers to as "the yummies."

The yummies are like honey on a hot, buttered biscuit.

Allow yourself to savor these small encouragements. Veganize them as you see fit. Think of any dairy-free, gluten-free alternative you want, but do not mistake the yummies for an indulgence.

They fill a legit nutritional need. Preserve them and they'll sustain you through many a long winter.

Like when you're tabling at a zinefest, watching legions of attendees who presumably love your subculture bypass your carefully arranged wares for something sexier, hipper, more colorful, or celebrity-oriented.

Or when you battle the elements to a gig only to find that none of your friends bothered to show, and the smattering of humans who are present want your mic lowered, so your original songs won't interfere with their conversation.

Or every joke falls flat, and the stand-up on before you slayed. Or nobody cares to comment on your art.

The yummies come in a wide variety of flavors, as evidenced below. This is no prideful self-tooting of horns but rather a response to my question, "What's the nicest thing anyone's ever said about you, in relation to your work?"

Karen is intrepid.
—Karen Christopher

Heather Riordan is just about the funniest thing on two legs.
—Heather Riordan

Shelton Lindsay, self-proclaimed as three parts glitter to one part mermaid, is turning art, gender, and everything in between on its head, and when you speak with him, you realize the great potential for tangent. His brain is unlike anyone else's, pulling thoughts and concepts ubiquitously. It's as if he's a hyper-intelligent being who's come from another world to show us how to be amazing.
—Shelton Lindsay

Colors are brighter, sounds and voices seem more harmonized and connected, and I feel part of some essential grace of life . . . after seeing Anthony Wills,

Jr.'s flawless and haunting performance of his one-man show, *The Happiness of Schizophrenia*.

—Anthony Wills, Jr.

Snakepit is hands down the best zine I've ever read.

—Ben Snakepit

You have such a beautiful soul. Thank you for all that you do.

—Stephanie Summerville

I know it seems scary but people like you and your podcast, and it is going to be okay, they will catch you.

—Drew Ackerman

Why aren't you sharing your voice with us?

—Sabrina Chap

You just haven't asked the right person yet.

—Akin Salawu

What did you just play?! Franny and Donna are upstairs crying their eyes out!!! You've got to put that song out into the world. Everybody needs to hear that song.

—Lorijo Manley

My fifth-grade basketball coach, Sherman Riggsbee, told me I could do anything that I set my mind to. No one had ever told me that before, and I took it to heart.

—Anonymous Funnyperson

A music journalist told me an essay I wrote about my teen heart throb obsession was the best piece of music journalism he'd ever read.

—Liz Mason

A young lady said my book inspired her to leave her bleak, small town in South Dakota, move to New York, and pursue her dreams.

—Trav S.D.

A janitor at college overheard me playing piano in a lounge. I didn't know he was there, and when I finished he appeared and told me he thought I was going to go places.

—Nick Balaban

A stranger passed me a note at a stand-up comedy open mic that said " You were the only one who made me laugh."

—Anonymous Writer-Performer

A homeless client who was in an art therapy group with me said the things I drew reached something deep inside of him and made him want to keep on getting up and fighting

—J. Gonzalez-Blitz

The New York Times called me "a comic gem."

—Bob Laine

Your work saved me.

—Moe Bowstern

As for myself, the kindest, most memorable thing anyone's said about my work is, "We've received your little pamphlets, and they're rather darling, but I'm afraid they won't fly in today's highly competitive marketplace."

Kidding!!!

I AM TOLD THAT THERE IS A SMALL TOWN IN COLORADO WHERE A CHARACTER I CREATED IS KNOWN TO THE CITIZENRY BECAUSE SOMEONE WHO SAW THE SHOW I CREATED IT FOR MOVED THERE & TALKED ABOUT IT ON THE LOCAL RADIO PROGRAM. APPARENTLY, IF YOU MENTION THE SPACE ALIEN MEGLOR TO FOLKS IN PAONIA, THEY WILL KNOW WHAT YOU'RE TALKING ABOUT.

GET SOME CHERRIES & ARRICOTS WHILE YOU'RE THERE.

ANONYMOUS
WRITER-PERFORMER

That's actually one of the worst. I've been on the receiving end of far uglier, but dude, it was my birthday. Plus, the speaker, a fancy literary agent recommended by a well-intended friend who was convinced my zine could become a book, had this *ridiculously* posh, lock-jawed, related-to-the-Queen-on-Mummy's-side British accent. This felt horribly definitive.

. . . little pamphlets?

"Oh, okay." No doubt I thanked her for her call. The curse of having been raised right.

Internally? "Fuck! YOOOOU!!!!"

Now and forever. It definitely made me hate pro forma rejection letters less.

But we were speaking of yummies. One of my all-time favorite yummies was embeddedinareviewpennedbyaguywhoreally,reallydislikedmyzine,andbyextension,me:

"Like Charles Dickens, Halliday sentimentalizes children and childhood." Dickens, you say? *CHARLES* Dickens? How *dare* you, sir!?

Ha ha! I really put one over on that guy! His words are now trapped for all eternity alongside the naked yummies of a bunch of hip mamas, young punks aspiring to eventual parenthood, prisoners, the late great feminist scholar Alison Piepmeier, and a whole bunch of other Dickensfuckers. Double your pleasure, and gather your yummies where ye may.

Giving Small Encouragements

Don't bogart those yummies.

Give some too.

Dole them out liberally to small potatoes you admire.

Even if you're shy and feeling tongue-tied.

Crib from the previous page's examples if the pump's in need of priming. Hey ho, let's go.

Giving yummies helps keep jealousy in check by siphoning off some of the toxins that can result in accidental self-poisoning.

Like most Westerners, I have an imperfect understanding of karma, but it seems to me fortune's inclined to favor small potatoes who aren't stingy with the yummies.

So go ahead.

Post a positive review.

Write a fan letter.

Hang out in the lobby after the show to thank the actors and the playwright, even if you're not personally acquainted. (After which, release them, especially if their eyes keep darting toward someone who's standing behind you, clutching a rose.)

It might feel awkward, or like another damn chore in your Sisyphean workload, but consider the reverse angle.

It's awesome that the *New York Times* called Bob a comic gem—(they're not wrong)—but such brand-name yummies are thin on the ground for spuds of our size.

That's a shame when such seals of approval have the power to spin hay into gold—wider audiences, increased sales, exciting opportunities . . .

Not always of course.

I can receive glowing reviews, but as personally fulfilling as that may be, it never seems to take my career to the next level. I don't get phone calls or emails from producers or artistic directors saying, "Would you be interested in doing this much more visible such-and-such?" Every time I launch a project, I have to go out there and hustle for publicity and audiences like my plane just landed at O'Hare (and I'VE BEEN LIVING HERE FOR 30 YEARS).

—Edward Thomas-Herrera

The yummies you give can provide both first aid and dessert. The fact that they are unsolicited makes them all the more precious. Unlike a paid reviewer, you were under no obligation to say anything . . . but you did. You took the time. What a mensch. Want yummies? Give some.

Surviving Criticism

There are small potatoes, and for that matter some big bananas, who claim that brutally honest feedback is the only kind they're interested in receiving.

Nothing hurts them. Not even googling their own name (though copping to that activity might dull the sheen of the image they're sculpting from polished granite). That's not the kind of toughness I gravitate to.

There is a part of me that is relentless. Even when I think I might give up, something inside just gets back to work.

—Karen Christopher

It's an almost animal instinct Karen's describing, or would be if animals had moments of self-doubt that could get blown out of proportion by the opinions of others. Animals have an admirable imperative to keep swimming, flying, pouncing, and slithering no matter how grievously wounded they are.

Are jellyfish also relentless? Because criticism, cold shoulders, and other unyummies can leave me feeling as spineless as one, though my imperfect, crafty human brain has come up with a number of baroque suggestions no animal's ever would, to help us survive to fight another day:

- Copy the hurtful unyummies out, build a fire, and pitch the paper in. Steer clear of the tree line and any neighboring structures. Ask the smoke to bear those bad feelings far, far away, and heal your festering memories thereof.

- Approach a hypnotherapist who's open to the idea of barter. Offer them a handful of zines, an album download code, or a personalized pet portrait in return for power washing your hippocampus.

- Look up contact info for the person responsible for the unyummies and send them a courteous email or postcard. Thank them for taking the time to share their day-making observations about your project (or talent in general).

Whatever holiday is approaching, wish them a happy one. Choose a pleasant sign-off. "Your pal" works for me. Don't punch down. Smother them in honey 'til they die of confusion and the arsenic they didn't detect until it was too late.

- Seek out an even-tempered comrade who belongs to the same scene as you and the fiend who fomented those unyummies. Privately secure their permission to fill their ears with the shitty thing so-and-so said about you and/or your work. Let them know you don't expect them to take sides. Thank them for allowing you to vent. Cling to, but do not repeat any consoling words they may offer—how so-and-so is as stodgy as fruitcake, a mouthy, immature pup, or a hothead with issues.

- Enlist a trusted confidante to resurrect those sour lemons as lemonade by giving them a Sharpie and the text of your nasty review. Tell them to strike anything that smacks of disfavor and add punctuation as they see fit. Once their revision is ready, ask them to do a dramatic reading. Isn't it nifty how quickly "uninspired" can become "inspired"?

- Research the 2004 glitch on Amazon's Canadian site that exposed every anonymous customer reviewer's identity for a week and close your ears to the demon who wants you to get even via subterfuge. You don't always have to rise above, but if you're going to wade in after your enemies, be brave and show your face.

- Hang out under a trestle and scream like a relentless barbarian when the train thunders overhead. Then give me twenty jumping jacks and exercise your diaphragm with some Kapalabhati pranayama, also known as skull shining breath. Emerge relentless and at peace with the idea that some people aren't ever going to get you. Their loss!

Practice Compassionate Criticism

Once upon a time, a venerable big banana confessed that the only thing he wants to hear in the tender first minutes following the debut of a new work is, "I loved it."

Even if you hated it.

Even if you have some constructive criticism.

I imagine not everyone will relate. I was certainly surprised to find myself experiencing a sense of kinship with this particular banana. My feelings toward him are extremely mixed, owing to some petty bitchery I best not get into here. But in terms of how new work should be received? I hear you, my brother.

Minutes after giving birth, I am not emotionally prepared to hear that my baby is merely okay. Or that my baby would be better if a piece of it were cut off.

Maybe later, after I've steeled my nerves and screwed on my game face. Not while my newborn is still streaked with blood and vernix. Give mama a chance to snap some pictures and deliver the placenta, okay?

It wouldn't be fair to put you on the spot, so I'm putting in an advance request: tell me you loved it. I try to be gentle when giving feedback, even if the person on the receiving end hasn't coached me to start off by telling them I loved it. It wasn't always thus. I cringe recalling my brisk condemnations of a long-ago classmate's story. It was about a man seeing a car hit his son's dog. I lit into him for an overabundance of exclamation marks and all caps and told him he'd better give the dog a better name if he didn't want readers to laugh when the main character screams it out at the moment of impact. Not a very nice way to treat someone barely out of his teens, or his hapless attempt to swaddle his childhood trauma in the sheerest veil of short fiction.

These days I'd lean on choreographer Liz Lerman's Critical Response Process, a four-step process in which you start with the yummies, then answer any specific

questions the creator may pose, then ask some nonjudgmental, neutral questions of your own, and finally offer some personal opinions if, and only if, the creator indicates they're willing to entertain them at this time. If they decide to stick with the yummies, rather than going for whatever's behind Curtain Number Two, that's their prerogative. One you should feel free to exercise, particularly around people who'd love nothing better to give it to you with no grease.

Bad Crowds

The Titan god Prometheus was a pretty creative dude.

That's not why Zeus chained him to a rock and sent a monstrous eagle to devour his magically regenerating liver day and night for all eternity.

Sure feels that way sometimes, though, particularly when we bomb. The curse of our relentless Promethean creativity!

It's dismaying to lay a rotten egg in front of people we care about, who have pledged to tell us they loved it no matter what. Beating our brains out in an attempt to make an impression on indifferent strangers? That's real eagle bait.

Here is one of our dear comrades, musician Nick Balaban, to tell us about a time his creativity got his liver ripped out:

Before it closed forever due to the ravages of petty and unregulated hyper-capitalism, I had a monthly gig at Caffe Vivaldi, a beloved Greenwich Village institution.

One night, I came in early, as usual, to check out the band before me and was struck by the numbers—a huge, young crowd, exuberant and loud. Apparently, a couple of newlyweds had decided to have their wedding party at Vivaldi. Before I went onstage, I struck up conversations with some of the folks and

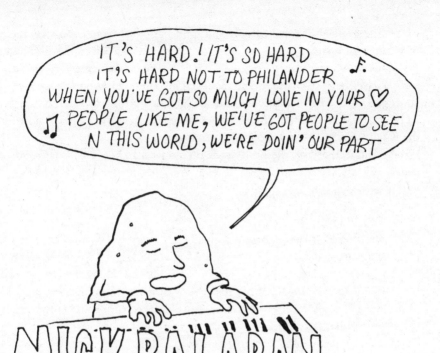

discovered that these twenty-somethings were mostly in finance, from all over the world as it turned out.

I was psyched to play for them and connect to a wider audience, and I had played Vivaldi enough to have picked up several techniques for engaging and entertaining the audience—holding court, asking a stranger in the audience

to introduce me using wild hyperbole, prefacing each song, most of them original, with a snappy, relevant story to pique interest before the first note. But. This crowd was not there for the music or the entertainment. They were there to celebrate this wedding, and clearly hadn't hired a location scout. I tried to converse with them as a group, and later as individuals, from my perch at the mic. At one point, I had a eureka moment. I announced that I had a special song for the happy couple. I talked about my own happy, almost twenty-year marriage. Having connected with the newlyweds themselves, I knew I had the room. I believe my last words were "This one's for you."

Then I launched into "It's Hard."

I lost them around "Debbie's a girl in the office . . ."

If that weren't painful enough for my quietly huge ego, at the end of the night, I emptied the tip jar and it was filled with hundreds of coins, most of them pennies. The bartender was mortified and apologized profusely, taking the change and converting it to bills. I assured her that this was not her fault, just bad human stuff. Before leaving, I went to pee in the small unisex bathroom in the back. It was desecrated, urine all over the toilet and floor, which had *never* before been the case at this classy joint.

Confirmation of bad human stuff. It was just weeks later that my beloved Caffe Vivaldi closed for good."
 —Nick Balaban

The moral, for those in need of moral instruction: If you're in finance, rent out an entire venue for a *private* function. Drop a few thou' less on flowers if need be. Don't fuck with a hard-working small potato's longstanding gig.

For the rest of us, there is no moral, only an opportunity for commiseration, a visceral aversion to eagles, and a renewed appreciation for small but responsive houses who know a toilet from a tip jar.

Take a Compliment

Nothing like that rowdy wedding party at Caffe Vivaldi to make a small potato yearn for words of heartfelt praise.

Yet being on the receiving end of such yummies makes many small potatoes feel awkward. It's okay to *feel* that way. Unacceptable to act that way.

When someone gives you a present, you don't throw it on the ground, grind it under your heel, and shit on it in front of the astonished giver. (I hope.)

Compliments are transactional. Why does someone go to the trouble to articulate their appreciation . . . especially if the prospect is an awkward one for them too?

It's true that these compliments can arrive at an inopportune moment, like when we're on the brink of a spat with our significant other, who's hung around supporting us for hours, and is now exhibiting signs of seriously low blood sugar.

It's also rough when we're feeling down on ourselves, convinced (not without reason, perhaps) that we did a shit job, meaning we're shit, our latest project is shit, everything we've ever done is shit . . . sing along if you know the refrain, and pity the clueless, beaming nim-nim who chooses that moment to gush.

Their timing may be off, but we are *assholes* if we can't bring ourselves to acknowledge their gift, simply and with as much sincerity as we can muster.

Entertain this possibility:

Maybe they gleaned from our stricken facial expression that we're having a doubtful moment, and *that* is what spurred them to approach. Small potato citizenship!

If someone praises you, let them.

Look, here's a script we can follow:

Whoops, sorry, wrong script. HERE'S the correct one:

Boom.

Now all that's left to do is thank them for showing up (or taking the time to write). Your end of the bargain has been fulfilled.

Clueless Fans

Touring musicians have a name for concertgoers who waylay them as they're coming off stage, conflating adoration with ownership, bombarding them with questions and long winded proofs of devotion:

Punishers

In the scrappy early-nineties Chicago theater scene, our preferred term was:

~~Punishers~~ Crazy fans

Eager to rid ourselves of casual ableisms, let's rerender that as:

~~Punishers~~ ~~Crazy fans~~ Unwelcome fans

Or, somewhat more fairly:

~~Punishers~~ ~~Crazy fans~~ ~~Unwelcome fans~~ Fans who awaken primitive mean cheerleader impulses

Or to really cut to the chase:

~~Punishers~~ ~~Crazy fans~~ ~~Unwelcome fans~~ ~~Fans who awaken primitive mean cheerleader impulses~~ Defenseless individuals who can't read the room for shit, but really, really like us us and what we do, are unlikely to sexually assault or murder us, and probably harbor a secret desire that one day we'll be friends.

Without naming names, there's someone fitting that profile who took an interest in me after a long-ago encounter at an annual outdoor art freak jamboree, where costume-loving showboats get treated like big shots by those who are content to take our picture and catch the candy we throw. Ever since that first chance meeting, whenever I've got an event, he's there.

And on the occasions when he's not?

He messages me to apologize and inquire how it went.

He creeps my friends and family out, and I can see why.

On the other hand, they weren't in attendance when he struggled in from a distant borough in a melonfarming blizzard for my part of a seriously underpromoted series.

It still frosts my ayuss that a drink and round-trip subway fare exceeded my portion of the door split. What a chump. I'd beaten the drum much harder than the organizers who'd roped me into this, too, drafted a bunch of new material, and spent hours researching the late female comedian the event was honoring.

They held the house for late arrivals. By the time the show finally got underway, I needed both hands to count the crowd.

Halfway through this grim ninety-minute charade, who should bumble in, upstaging me with his rustling plastic shopping bags, but my defenseless individual who can't read the room for shit but really, really likes me (and to a lesser degree, what I do), who is unlikely to sexually assault or murder me, and who clearly harbors a secret desire that we'll be friends one of these days. Right on schedule, for him. The popular girls who talked shit about me in middle school would've torn this guy

to ribbons. Not for fucking up the timing of something they'd rehearsed. Just for the presumption of existence. He does presume. He presumes that I will receive him. Because that's what this chapter is really about, not Gilda Radner or the still-living human beings I stuck it to in a diary-based, Memorial Day weekend puppet show hardly anyone saw. (If you don't know who Gilda Radner was, for god's sake, look her up, and maybe reread Ozymandias for good measure.)

In the past, I have tried to get out of interacting with him, scanning the room in search of anyone else to talk to, prolonging the final conversation, hoping—in vain, obviously—that he'd wander off unacknowledged.

Something about this particular evening, as shitty as Nick's night at Caffe Vivaldi but for different reasons, did something to my inner mean cheerleader. It was a surprise to find myself making a beeline to you-know-who.

That's right, folks, before I said hello to the late comedian's best friend's niece, who'd earlier called me out for mispronouncing her uncle's last name during a not particularly jolly trivia quiz, I voluntarily approached my "punisher." I may even have hugged him . . . gingerly. We exchanged some weather-related remarks. God bless snow.

THE SMALL POTATO MANIFESTO

WE RELISH THE FREEDOM OF OUR RELATIVE
SMALLNESS WITHOUT HOPE OF WEALTH.
THE ONLY TIME WE GET IT WRONG IS WHEN
WE AVOID DOIN' IT. WE CHOOSE WHEN TO BAIL,
AREN'T SCARED TO FAIL & CROSS THE FINISH
LINE WITH A MIGHTY YAWP. OUR LOINS ARE
GIRDED FOR THE LONG HAUL. WE LIFT
OTHERS UP & WELCOME SUPPORT FROM
ALL QUARTERS.

7. THE WORLD OF SELF-DOUBT

Quit Yer Bitchin'

Sometimes, like Eeyore, we wallow in glumness. Nobody likes us, nobody appreciates us, nobody cares.

Why bother working when nobody gets our work? Why paint a picture no one will see? Why write a song if the only thing we get from singing it is a sore throat? Eeyore is so wed to his culture of complaint, he never gets a damn thing done.

I'm aware that according to some interpretations, Eeyore is clinically depressed. Perhaps he is. He's an icon of 'em.

For our purposes, Eeyore is a stuffed donkey entrenched in his lone-wolf ways.

But the Hundred-Acre Woods emphasizes community. Pooh, Piglet, and all the other denizens of Christopher Robin's childhood days spend inordinate amounts of energy dragging him into whatever group project they've got going. What would he do if they didn't exert themselves so on his behalf?

Chip away at some solo work 'til it fizzles, thus confirming his world view? Or mope around the sad old pile of sticks he calls home, pissed that none of his so-called friends bother to check in. He could be dead for all they know!

Interacting with Eeyore is always a bit of a chore, and sometimes, it's involuntary, too.

Who among us has not served on a committee with an Eeyore? Their litanies of complaint suck all the oxygen from the room and much of the joy from any shared task.

I find Eeyore exhausting. Does he enjoy being so much work? Would it kill him to shut up and try once in a while?

I'm pretty much a Tigger—publicly, anyway. Those who think I'm perpetually bouncy, trouncy, flouncy, pouncy, fun, fun, fun, fun, fun might be surprised to learn my inner child is a shy one. Sweet baby Jesus, may they never catch sight of the bummer donkey hiding just behind my stripes. I don't want to be a drag on the group. I don't want to poison anyone else's good time. I don't want to be seen as contributing less.

Which leaves the person who's been my sole romantic partner since the early nineties to bear the brunt of my Eeyore.

If there's a steady presence in your life who is mostly patient and gentle with your Eeyore, be glad of it.

It's a selfless gift they're giving you (and the unsuspecting members of your group).

Pie is for Sharing

The way I process others' success tends to be less about jealousy and more about feeling disappointed or ashamed of myself. It's a self-squashing comparison and is difficult to prevent.

—Connie Fu

I get it. Sometimes it feels like we're all engaged in some sort of cosmic pie-eating competition.

Maybe we are. In which case, allow me to state that there's plenty of pie to go around, even if we're not all served at the same time.

When success happens to someone I know, I'm closer to successful people, which makes me feel like I'm a part of something.

—Nick Balaban

I am the first to be excited for a friend or colleague who's booking a gig or winning an award. Their success does not take away my chance at success. What often happens is that I basically pep talk myself to do more, practice harder, be better so that I can live up to my friend's successes. This business is hard enough, we have to support each other on the way up.

—Christine Schisano

That's a good policy to adopt, even if it turns out we're wrong, and the pie supply is, in fact, extremely limited. If that's the case, best to remember there's no one factor determining which of us gets handed a fork.

So much of the art world is about timing, about who you know, about the zeitgeist . . . it's comforting to remember that your successes and your failures are not totally your responsibility either way. That's liberating.

—Shelton Lindsay

What would you do if you had a big tasty pie all to yourself?

Reserve a few pieces for latecomers?

That's a very community-spirited way to de-escalate any situation where people are pressed up against the glass, screaming, "Nice of you to save us some, you fucking asshole!"

You could drive them to the pie shop and buy them a pie of their own to share. And contribute to their bake sales before they ask.

Someone Else's Shoes

I get jealous of people even when we're nothing like each other. I somehow think, if I were them, I'd be having an awesome life. It fucking sucks.
—Winter Miller

Heavy is the head that wears the crown, but what about the foot that fits the glass slipper? Wouldn't you like to slip your hooves into one, or preferably, two of those for a sec?

Imagine the comfort! No doubt they've been engineered to have a massage effect on every conceivable level—mental, spiritual, situational.

We don't hear much about the ingrown toenails, the bunions and corns. Would we be sympathetic? Or would we think, "Quit bellyaching and get your fairy godmother to turn a mouse into a podiatrist, why don'tcha?"

Yet, every life is rife with bumps, setbacks, and disappointments. Some are marked by genuine tragedy. Thinking about that makes me a better, more empathetic human. Sometimes it makes me a little impatient with my own whining.

Life has taught me that each person has a very different set of circumstances. It's silly to be jealous of what appears to be a good thing happening, when you don't

actually know what that feels like to the person, or the other shit happening in their lives.

—MariNaomi

Making art is really hard regardless of who we are. I think about great artists who died in obscurity and poverty and misery.

—Moe Bowstern

I feel jealous of people who seem well-adjusted and have good social skills or really honed craft or big, well-spoken brains. Sometimes I just feel "less than." I manage this by saying that they are doing it *their* way in *their* voice, and my success is just different. And maybe someone out there is feeling the same way about me (even though I would tell them they are wrong).

—Drew Ackerman

I remind myself that I have a lot to be grateful for—health, a loving family, a theater, food, clothing, shelter. I am also thankful for the way in which I have received opportunities in a timely way—I have gotten opportunities when I was ready for them.

—Meghan Finn

Managing Jealousy

A Jealousy Management Seminar doesn't sound particularly inspiring to me, but I like the idea of a jealousy management junk drawer.

Perhaps if we root around in a tangle of our comrades' loose birthday candles, aged business cards, and brittle rubber bands, we'll be prepared with the perfect random thingy to prop up the three-legged tables of our imperfect natures the next time jealousy tilts the floor.

When artists whose work I don't love get recognized, I can get distracted by anger. When that happens, I put on my tap shoes and show up at a party full of people I only kind of know, and tap dance (a thing I only glancingly know how to do) until they pay attention to me.

—Emmy Bean

If they are talentless hacks who don't deserve success, I think of all the things they must be giving up to achieve that success: privacy, equilibrium, sobriety, etc.

—Anonymous Writer-Performer

I imagine that I am very close to the subject of my envy and question whether I still feel envious. It doesn't solve anything but it does defang the notion that it isn't deserved—I do enjoy when people I know and love have success or appreciation, so it goes easier if I imagine that would be possible with anyone I feel envious of. I also keep a bright eye on my own relative success and weigh that against what might be the burden of spectacular success.

—Karen Christopher

My discipline, textile and fibers, is slow and requires much patience, so the discipline itself helps counterbalance the mental forces that push me to run faster, harder, in comparison to others.

—Connie Fu

I think I'm generally a little too self-centered to be jealous, which is helpful. That said, there are a few specific people I get jealous of—a few who are at my level, basically, and a few who are above where I'm at, whose lives and accomplishments I'm envious of. I manage it by focusing on how fortunate I've been in my own successes, such as they are, feeling grateful, and keeping my eyes on my own work.

—Ellia Bisker

I might be jealous of another's success for half a second but then I get over it, because no matter what that person is doing, it is different than what I do. For example, why would I be jealous of another writer's success if what they write about or the form they write in is nothing like what I do? I don't even write poetry.

—Liz Mason

I deal with jealousy for others by vowing to beat them.

—Trav S.D.

Jealousy is a very human experience. Sometimes you just have to feel it.

—Akin Salawu

8. DEFINING SUCCESS

Get Rid of Your Baggage

The dreams that set us on the path to becoming small potatoes (or, in rare cases, big bananas) can load us down with heavy baggage. The kind that would fit right in aboard the Titanic. Behold the vanity cases! The garment bag with built-in hangers and a travel iron for dewrinkling formal wear! The steamer trunks stuffed with trombones, unfinished manuscripts, and gypsum!

When I was just starting out, I envisioned success like Hollywood portrayed it to me —see *Inside Daisy Clover* with Natalie Wood for details. I honestly thought the challenge would come from one initial big, bad obstacle. Once that one thing was conquered, that would be it and life would be easy from there.

—Stephanie Summerville

I envisioned success as being discovered, being taken care of. Getting a contract from a label or a publisher, an authority figure or gatekeeper entity who would pick me out of the crowd of aspirants and validate my specialness. Your basic Sugar Daddy / Prince Charming fantasy.

—Ellia Bisker

I thought I'd have the careers of Michael Jackson, Ben Vereen, and Lavar Burton rolled into one.

—Anthony Wills, Jr.

I really wanted to live by the notion that if you do what you love you never work a day in your life.

—Liz Mason

Broadway! That is/was the dream. Being on a big stage and getting to live these historic characters every night to sold out audiences. Wearing wigs—lots and lots of wigs! My focus was only on the very big endgame move. I was not thinking about the long, drawn out chess game to get there.

—Christine Schisano

Chandeliers, chaise lounges, poodles, furs, diamonds, swimming pools. Actually I do have the chandelier and the pool now.

—Mimi Pond

It's encoded in our DNA, I think. To start out wanting to make a splash in the arts. You know what else makes an impressive splash? Heaving your baggage overboard.

The Tootsie Pop of Fame

Shortly after moving to New York City, I stumbled onto a movie set on Sixth Avenue. I had some time to kill before rehearsal, so I decided to treat myself to a good long gander. I was hanging over the barricade with the rest of the rabble when I heard someone say my name. Good heavens. A guy I'd done improv with in college was the star of this movie.

He was also starring in a TV show that wound up permeating the zeitgeist so thoroughly, two years later, the medical professionals tending my vagina after a highly traumatic labor and delivery avidly discussed his character's previous night's antics over my non-dead body.

(For once, I'd refrained from bringing up my personal connection.)

His recognition of me caused a stir on my side of the barricade . . . the kitchen maid transformed into Cinderella.

"We're all so happy for your success," I told him. I'm not sure who "we" was meant to imply. The ole improv gang, most of whom I hadn't heard from in years? Everyone we went to college with? Or just the ones who hadn't wound up on a hit TV show?

"Eh . . . it's all a bunch of bullshit really," he shrugged. I appreciated the attempted modesty but wasn't quite willing to let him off the hook that easily, given the barricade and all. "Yes, and" is the first rule every improvisor is taught, but occasionally those of us with a bit more experience can indulge in a bit of "Yes, but." As in, "Yes, but I bet if you take a bite of that bullshit, there's a big roll of money inside!"

And . . . scene.

False Modesty, the Worst Kind of Humility

That guy's just one of *many* people I went to college with who blew up huge. Listen to this!

Another pal got cast on *Saturday Night Live*! The two of us were never all that tight, but we have a close mutual friend and were both part of a group who got together when that friend was in town.

Our party was strolling from the apartment where we had gathered to the park where we planned to picnic, a big enough crowd that we broke into pairs so other pedestrians could squeeze past.

Guess who I found myself walking alongside? It was a double treat, given that our mutual friend had commandeered my toddler, freeing me up for some adult conversation with an adult who didn't want to talk about children.

Instead, she talked about how awesome it was to sing a duet with guest host Samuel L. Jackson as part of a recent sketch. I hadn't caught the episode she was referring to, having stopped watching *Saturday Night Live* years earlier, but all the same, I was impressed.

I was equally impressed that my schoolmate's success didn't make me want to curl up weeping over what might have been. It helped that I was, at the time, the only person in attendance to have had a baby. There was some weird status in that.

But more so, it's because the big banana in our midst didn't downplay her good fortune with talk of brutal hours, tiny dressing rooms, and bad deli sandwiches. She didn't condescend. Instead, she dished on guest hosts and hilarious costumes and Lorne. She had grabbed the brass ring, and I was glad of the opportunity to inspect it up close.

Being regaled with insider tales of *Saturday Night Live* made up for all those times I, the eldest of four cousins, was exiled to the children's table whenever the extended family gathered at my grandparents' for holiday dinner. I didn't feel demoted. I felt included.

And I didn't feel "less than" telling her about my nascent zine. In fact, I was—and am—quite proud. I hope I presented her, and everyone else in attendance, with a complimentary copy. Big bananas aren't the only ones capable of providing party favors.

If You Had One Wish

IT'S YOUR LUCKY DAY!!!

Put down the lamp and start rubbing this book! Mmm. Yeah! Feels good, thanks! Don't forget to have a wish in mind, should a genie materialize to grant you one.

A team—a manager, a web team, someone to take care of the technical shit, and a press person.

—Sabrina Chap

A free transcriptionist for my interviews! And someone to handle all the technical issues that arise.

—Rachel Kramer Bussel

An Audio Engineer Supreme who could transfer all of my recordings in various mediums from across the years into formats that I can actually use.

—Lorijo Manley

I want someone else to take care of the business angle. Ideally someone would go, "We'll take all your zines and put 'em in a book every time you put out a bunch of more issues! Then you don't have to keep all of them in print and find space for them in your house! And we'll sell these books for you!"

—Liz Mason

A big orange head. (Remind me to tell you this joke sometime!) I guess at the moment I'd like a booking agent who I could trust to do a better job than I'm doing now.

—Ellia Bisker

A proper mentor/coach/work buddy, someone to check in with regularly, an editor who is part pal. Like a gym buddy but for my creative work, who has tons of time for me and only puts up with a little bit of my bullshit.

 —Moe Bowstern

An Artistic Director who loves me unconditionally, but nobody will ever be that silly.

 —Rob Ackerman

A house in the Midwestern area of my choosing with no major infrastructure problems, paid for in cash, in full.

 —Anonymous Zinester No. 1

A space in NYC that I own.

 —Anthony Wills, Jr.

The ability to work my job on a flex schedule without guilt. I like my day job, but some of the nine-to-five drags, and I feel like I'm just wasting my time there.

 —Anonymous Zinester No. 2

Health insurance for my whole family.

 —J.T. Yost

. . . a monthly stipend?

 —R. Sikoryak

More hours in the day to myself.

 —Anonymous Writer-Performer

Freedom from self-sabotaging beliefs.

 —Stephanie Summerville

The gumption to keep on going.
 —Karen Christopher

A Think Stopper to stop overthinking.
 —Drew Ackerman

For misogyny to go away.
 —Mimi Pond

To go back to college and do it better.
 —Akin Salawu

For Eric's illness to be cured.
 —J. Gonzalez-Blitz

Pure enlightenment.
 —Anonymous Funnyperson

What? The genie is gobsmacked by the overall modesty and practicality of these hypothetical requests. Money, time, and space are not unreasonable . . . maybe a bit *too* not unreasonable.

Come on, people, have we small potatoes gotten so good at managing expectations that we're content asking the Monkey's Paw for a turkey sandwich?

Are we worried the genie will think we're overreaching?

Don't wanna be the death-row inmate whose proposed last meal is deemed too spendy?

Listen, we're all good at hustling and making do on the cheap, and many us have a legit horror of being "wasteful," but if ever there were a time to put in for a baguette-sized penis and faucets dispensing eclair filling from our mansions' walls . . .

I'm calling a redo.

Okay, How about Three Wishes?

This time you're getting three wishes, and there is no such thing as a greedy answer. Think of it as a reminder that we needn't always confine ourselves to the meagerest portion.

More genies! More wishes! I'd like to be an incredible singer.
—Winter Miller

Now we're tawkin!

Ughhh okay, if I had three wishes, I would wish for an amazing multipurpose arts studio/live-in dream home, that, let's say, is invisible and can fly, so I could float around making art installations in my studio jet, reminiscent of what the Avengers have when they fly around saving the world from super monsters. And because I think transport and green energy will help create a world where we can have excess time to devote to art-making, I'd wish for the power to completely reorganize public transport infrastructure across the whole world, including planting many trees, which would be helpful because then the world might not end, and I could continue making art. And then I guess lots of funding.
—Shelton Lindsay

Ha! A straight-up life stipend for both me and my spouse at around $115k a year. We're both creatives and would never have to work again. We could focus

on being supportive to our families—parents, grandparents, and nieces spread throughout the country and world. Also the ability to teleport.

—Anonymous Zinester No. 2

A free space somewhere in Manhattan where I could rehearse and produce plays whenever I wanted. A fully equipped recording studio for film, audio, and video. And, most importantly, an audience to come see and hear the work.

—Greg Kotis

A place in any European metropolis where I could work on my craft and live comfortably. An ensemble of like-minded artists with complementary skill sets, with whom I could create fabulous theatrical projects that would generate income for us all.

—Stephanie Summerville

The aforementioned *Queer Eye* makeover, an annual month-long all-expenses-paid trip anywhere I want to go, and a printing press.

—Steven Svymbersky

I would wish for an end to the fucking concentration camps in this country (and in China and Russia and probably a few other countries also) and to replace the Chicago police force with a highly coordinated team of unarmed grandmas delivering food. (Grandmas who are currently cops get to retire and raise sheep.)

—Emmy Bean

One Broadway hit, five million dollars to start my project to end immigrant child incarceration, and that house in my neighborhood where the famous dude lives.

—Meghan Finn

Perfect vision and the ability to speak at least five languages fluently.
—Christine Schisano

A wonderful piano teacher and someone who can get my songs to Bette Midler.
—Sabrina Chap

More storage space and for some (or all!) of my good friends to move to NYC.
—J.T. Yost

Someone to share my life and art with, and not needing a day job.
—Bob Laine

Eighty-four million dollars and a wealthy entrepreneur husband.
—Akin Salawu

A Pulitzer and MacArthur, not in that order.
—MariNaomi

A day-ender where I could just end my workday satisfied. And candy and a movie ticket . . . or a candy movie ticket so that it only counts as one wish.
—Drew Ackerman

I wish to master my habits, and I wish to be liberated and help others do the same.
—Maria Camia

Hahaha, a bunch of money, I guess? I dunno, I'm pretty happy. If a genie offered me more wishes, I'd give those wishes to you, Ayun
—Ben Snakepit

Are you sure?

Okay, well, er, I guess I'll say free postage for life, a preternatural ability to memorize and retain lines well into my nineties, and the sort of *New York Times* obituary that leaves readers wishing they'd known who I was when I was alive.

Make or Break Tater Traits

Most small potatoes will make it to the grave without *Vanity Fair* publishing our answers to its Proust Questionnaire.

What a rip, huh?

Whether or not I'm familiar with the big banana occupying the hot seat, their responses always fascinate. Especially if I suspect they're fudging it a bit.

It's statistically fishy to me that so many high rollers pick their moms as their greatest hero, their children as their greatest achievement, and whoever they're currently partnered with as the greatest love of their life. Proust himself would call bullshit on the sheer volume whose "idea of perfect happiness" is farting around with the kids and the dog on a quiet Sunday afternoon. Maybe this is another small potato blessing. We need never fear being forced to choose between the truth and a lie that'll make us look good for not hurting our family's feelings in a national forum. And the flunky who would have been administering our questionnaire will be spared our wrath at being asked to differentiate between our "favorite quality in a man" and our "favorite quality in a woman." I'm most interested in the answers dealing with good and evil.

What traits do I find most admirable and most deplorable in my fellow small potatoes? Probably the same traits my fellow small potatoes find most admirable and deplorable in me.

ELLIA BISKER

I admire bigness in small potatoes—a bigness of imagination, generosity of spirit, integrity, and risk-taking. I admire small potatoes who have an awareness of all the potatoes around them, big and small, and of their place in the potato-sphere. I admire those who make what they make in the place where they are, connecting as much as possible to the people, things, land, animals, and resources in that place, and acknowledging and addressing the inequities that exist in those places.

—Emmy Bean

Here are the rest of our answers.

ADMIRABLE TRAITS OF THE SMALL POTATO	DEPLORABLE TRAITS OF THE SMALL POTATO
DIY sensibility	Anger
Willingness to pitch in	Jealousy
Non begrudging acceptance of their small potato-hood	Ego
Could give fuck-all about what others say	Shit talking
Tenacity	Giving up
A very strong worth ethic	Lack of follow-through; Lack of Stick-to-it-iveness

ADMIRABLE	DEPLORABLE
Creating art for its own sake, not for money or fame	Desperate grabs for attention
A willingness/need to express their values through their art	Adding people to their mailing lists without permission
The ability to communicate their perspectives passionately	Complaining
Encouraging to other small fries	Self-flagellation
The desire to create without the need for validation	Not being upfront about where their funding comes from
Honesty	Not being upfront about what life is like behind the scenes
A quirky point of view	Churning out the same stuff over and over
Independence	Entitlement
Dedication to creating their own world	Lack of reciprocity

ADMIRABLE	DEPLORABLE
Sense of community and local impact	Lack of editing
Sense of connection to elders	Pricing their work obnoxiously high
Acknowledgement that we hold each other up	Paying more attention to the way it's printed than the content of the work
Drive and hustle	A focus on what isn't working instead of what *is*
Friendability	Premature diva attitude
Some seriousness, but also a sense of fun	People who lean heavily on their small potato communities only to then scorn them later
Humor	Tardiness!
Bravery	Workaholism
The ability to get the job done with what you've got to work with	That social climber quality
Interesting stories to share	Scarcity mindset

ADMIRABLE	DEPLORABLE
A sense of participatory gratitude	Intentional blindness to the work of others
Willingness to be alone in their joy	Devaluing the pond where you started
Self-belief	Fear of insignificance
Competence	
Kindness	
Vulnerability	
The ingenuity to cleverly leverage all of your assets for maximum results	
Grit	

Circle any that resonate, and for good measure, add your favorite food. I don't get why that's never been a part of the questionnaire. Such preferences are always revealing and very likely true.

THE SMALL POTATO MANIFESTO

WE RELISH THE FREEDOM OF OUR RELATIVE
SMALLNESS WITHOUT HOPE OF WEALTH.
THE ONLY TIME WE GET IT WRONG IS WHEN
WE AVOID DOIN' IT. WE CHOOSE WHEN TO BAIL,
AREN'T SCARED TO FAIL & CROSS THE FINISH
LINE WITH A MIGHTY YAWP. OUR LOINS ARE
GIRDED FOR THE LONG HAUL. WE LIFT
OTHERS UP & WELCOME SUPPORT FROM
ALL QUARTERS. FIE ON THOSE WHO WOULD
RATION OUR METAPHORS! OUR GRIT
DISTINGUISHES US FROM THE BIG
BANANAS.

9. BETTER TOGETHER

Growing Community

My hope for myself as a small potato is to be a part of a community, to make or publish art that is empathetic and encourages different points of view.

—J.T. Yost

If you crave community, grow one.

Some small potatoes do this from a very young age, confidently founding lit mags, organizing group exhibitions, and hosting monthly open mics.

Others are slower to recognize their capacity to lead, possibly because they suspect it's a lot of work.

Doing an anthology can be difficult. It can be a challenge wrangling so many contributors and trying to keep to a basic deadline.

—Delaine Derry Green

It's true that there's a lot of admin. There's a lot of admin to waiting tables, too. There's a lot of admin to answering reception desk phones. There's a lot of admin getting your kids to all their various activities.

I can't juggle for shit, but I can select a musty book and coerce eight or so of my fellow small potatoes to read it, create a brand new piece inspired by it, and very shortly thereafter, share that piece before an audience that only rarely tips into the triple digits. What's in it for the participants?

Twenty-five bucks and a work that wouldn't exist but for my weird ongoing project. What's in it for me?

Community. A very specific sort of one-night-only community orchestrated by me. My hope is that every performer leaves feeling their contribution was valuable and warmly received, and every audience member leaves feeling like they're a part of something, especially the ones who came alone.

> I think the hardest tendency to reckon with, and one that I see in myself very much, is the tendency to overlook relationships and opportunities in your immediate field of vision and focus on something that seems bigger, sexier, and shinier when it is precisely the strength of the smaller relationships and opportunities that makes the bigger, sexier stuff possible.
>
> —Emmy Bean

I have no illusions about the market prospects of an oddball variety show whose antiquated themes change monthly and whose concept can be tricky to explain, let alone justify.

But it gives me such a good feeling, there are many times I wish it were my main gig. So I could *really* resent all the time I spend on admin.

Group Efforts

Remember the story of the *Little Red Hen*? She harvests the wheat, grinds the flour, mixes the dough, etc., and nobody shows the slightest inclination to lend a hand until it's time to eat the loaf of homemade bread she pulls from the oven.

Temperamentally, I'm much closer to the lazy cat, the lazy rat, the lazy pig, or any other dilettante lolling in the barnyard, wondering where that hen gets her energy.

But there is one aspect of the hen's personality that feels uncomfortably close to looking in a mirror: her enduring hopefulness that her efforts will evolve into a group activity. She's not opposed to doing all the organizing. The bread was her idea, after all.

She just wants a bit of company in the furrows, at the mill, and in the kitchen. Not too big of an ask, given that everybody's going to want a slice. Once upon a time, I was irritated by this hen. She was so bossy. A nag. Also, I had a strong preference for animals with fur.

I have more sympathy for her, now that I'm an adult who regularly wrangles large groups of artists.

I burn a lot of time trying to figure out how to get a response from participants who didn't bother responding to my last four or five emails. It's hard to find the sweet spot. I don't want to come off as curt or passive-aggressive. I know they're doing me a favor. It's just a lot fuckin' easier to stay mindful of that when they don't act like it.

Everyone wants to be in the show. Nobody wants to promote it.

I don't deny anyone bread, but I'll admit to seething internally a bit more than I would like.

Let's endeavor to never put another small potato in the position of being a Little Red Hen. All that scorekeeping can really put a damper on their enjoyment of the bread they've toiled so hard to bring to the table.

THE SMALL POTATO MANIFESTO

WE RELISH THE FREEDOM OF OUR RELATIVE SMALLNESS WITHOUT HOPE OF WEALTH. THE ONLY TIME WE GET IT WRONG IS WHEN WE AVOID DOIN' IT. WE CHOOSE WHEN TO BAIL, AREN'T SCARED TO FAIL & CROSS THE FINISH LINE WITH A MIGHTY YAWP. OUR LOINS ARE GIRDED FOR THE LONG HAUL. WE LIFT OTHERS UP & WELCOME SUPPORT FROM ALL QUARTERS. FIE ON THOSE WHO WOULD RATION OUR METAPHORS! OUR GRIT DISTINGUISHES US FROM THE BIG BANANAS.

⑩. LEARNING

Is That Diploma Worth It?

Forget Harvard and MIT. People who get turned on by STEM early enough to major in a related area at institutions of higher learning tend to not become small potatoes. I wonder if their diplomas are stamped "EMPLOYABLE IN CHOSEN FIELD."

Mine sure wasn't. And I definitely didn't need it to secure my few dozen day jobs.

As a rule, small potatoes do not require college degrees, though a number of us have them. Whether or not we have them in the right subjects is up for review. I majored in theater at Big Banana University.

A fair number of the instructors I encountered en route to my aptly abbreviated BS were themselves small potatoes who gravitated toward teaching as a means of survival and guaranteed summers off.

And some of them made a deep impression (mostly positive). But ultimately, experience gets the credit as the Teacher Who Changed My Life.

I majored in English—creative writing, with a minor in French. I would be more serious about music if I could do it over again, like at least a minor in music. And majoring in creative writing as an undergrad was dumb, because I knew nothing. I would have been better off sticking to literature.
—Ellia Bisker

I was a double major in women's studies and political science. I wouldn't change it even though business might have been more useful to my creative career.

 —Rachel Kramer Bussel

I so wish I had double majored in my undergrad, either in physical therapy or nutrition. But I was young and foolish then.

 —Heather Riordan

Remember the guy I did improv with in college, the TV star who bit into a bunch of bullshit to reveal its chewy green center? He's not the only Big Banana University alum who made a shit ton of bank and our alma mater proud. Our very public achievements include, but are not limited to, marrying the Prince of England, then telling the royal family to get bent.

I loved my time at BBU, but there are many things it failed to teach me. Possibly the fault lies with me. I was so preoccupied with romance and taking the train into the city at every possible opportunity, I may have inadvertently missed some crucial lessons.

I wish art schools would also teach us how to make selfless service to others—art beyond ego. Art that heals the community, as opposed to me just working out my woes.

 —Maria Camia

I wish the arts program I attended in college had prepared me for running a business in *any* way.

 —J.T. Yost

I wish I'd taken it more seriously. I wish I'd known that dropping out of college was a bad idea.

—Ben Snakepit

I wish I'd known how utterly the rich and well-connected really do dominate all fields, including show business and the arts, traditionally a pathway for the working class. Want to be a playwright or an actor? Not having gone to Yale or someplace similar appears to be a huge bar.

—Trav S.D.

I wish I'd been self-possessed enough to realize that what I liked best about theater was the camaraderie born of shared experience and, with apologies to the couple in the next booth, all the little flubs and triumphs theater kids rehash at top volume in the pizza parlor after the show. I also liked the flirtation and the smell of the greasepaint. Literally. The aroma of those oily, flesh-colored sticks littering the dressing room counters of my youth cannot be beat, especially when mingled with a whiff of orange Fanta from the vending machine . . .

What did it smell like?

Escape. Acceptance. Autonomy. Stories. Sex.

None of these things would have been off the menu had I traveled a different avenue. I just wasn't familiar enough with the territory to know if any other avenues would be a good and satisfying route. As for the destination, I definitely hadn't internalized

that the one I had selected required discipline and expectations that can't be fudged at the professional level.

My family offered zero pushback, as I went about packing for freshman year, all my eggs shoved into a single, impractical basket.

I'm fortunate that way. Or am I? On a visit back to Chicago with my three-month-old baby, I met a new member of my old theater company. He was a second-generation immigrant whose parents had insisted he study something practical. So he became a pediatric echocardiogram technician, which sounds like one helluva day job to me. In addition to paid vacation time, health insurance, and a retirement plan—all fruit I've yet to taste—he's performing actual, quantifiable good.

I no longer wonder what would have happened if I had done what I was "supposed" to do after graduating with a degree in theater from Big Banana University—pursued auditions, a commercial agent, and conventional success. I'm not trying to be modest here. I'm pretty sure the likeliest outcome would have been a string of credits reading: Baseball Fan #3, Woman in Car, Mayor's Wife, Cashier, Customer #2, Birthday Party Clown . . .

Instead, I wonder what would have happened had I gotten my shit together to become a pediatric echocardiogram technician, like Steve.

Learning On the Job

The editor in charge of my longest-lasting freelance gig is forever assigning me topics of great cultural and historical interest. It's been quite an education. Seriously, I might as well have studied china painting and flower arranging at Big Banana University. That's how little I know.

I'll admit my ignorance to *you*, but the last thing I need is some anonymous online jagoff busting me on it in the comments section of my post (though, I'll admit, I took some pleasure from the troll who called me stupid, while also assuming I was a man and a millennial). To make myself seem passably conversant in subjects I know nothing about, I must venture deep into various Internet rabbit holes, a practice which frequently means I wind up earning less than minimum wage on any given article.

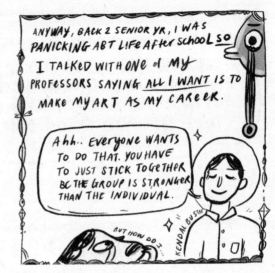

What can I say? No business major is ever going to conceive of me as "smart," but perhaps someone else will, seeing me write with such far-ranging mock authority. Georgia O'Keeffe's recipe box. Napoleon's arsenic-laced wallpaper. Kermit the Frog's TED Talk. The Hobo Code of 1889? Is there anything I can't hold forth on after a few hours of frantic digging? Sometimes I have some familiarity with whatever I've been assigned, and that helps me vamp a little. But the vast majority of my assignments are like showing the Second Law of Thermodynamics to a cat. They reveal incredible knowledge gaps. I'm grateful for the opportunity to learn . . . even about science, which does not come naturally to me, though I'm increasingly glad it exists.

Teaching

I was an adjunct professor for a decade. Loved it. Wish I still did it. It can really sharpen your skills: make you feel more comfortable, hone your improv chops, reinforce quick thinking . . . and as a day job, it keeps you immersed in the arts.

—Bob Laine

How I envy Bob that experience! The closest I come is impersonating a visiting professor to gain access to Columbia University's restrooms.

I discovered how much I enjoy teaching while bartering my labor so my kids could attend a nifty sleepaway camp, tuition-free. I would have peeled potatoes all summer long, but the camp director looked at my resume—zines, comics, plays, the low-budget hustle—and figured there was nothing there that I couldn't teach children to do too in a handful of hours after lunch. No offense taken. It was a good place for me to start, with no rubrics, Common Core Standards, or grades.

I came up with my offerings by thinking about things I would have wanted to sign up for as a camper.

I had about as much experience designing a curriculum as I do coaching football, but I was able to bluff my way through.

It probably helped that I have a performance background, a belief in the calming effects of deep breathing, and an abiding need to make people feel seen and included, even when they are dumping an entire bottle of glue onto a project that's supposed to be dry enough to move back to their cabin after snack.

The lack of a master's degree doesn't bar you from teaching. In my opinion, a bloviating self-regard that leaves no room for other people should be what bars you

Altered Books (aka Palimpsests)
Duct Tape Superhero Suit
Design Your Own Flag
Viking Funeral

from teaching. Small potatoes rarely think they know it all and usually have a lot to offer, particularly in forums where students are free to think outside of the box, on top of the box, or with a tinfoil covered box on their head because they want you to refer to them as RoboTron2500.

> I teach zine workshops, which are really more like writing workshops. If you're giving students time to work on a project during the workshop, work on that same assignment yourself while they're doing it. Then be the first person to show your work when work time is over. It emboldens and inspires your students.
> —Liz Mason

Teaching helps me make money. If I didn't need the money, I'd free up my schedule to do more of my own work. Teaching has, however, helped me think critically about my art forms, particularly improv and sketch comedy and why I make the choices I do when I'm doing them.
—Anonymous Funnyperson

There is very little money in the theater, so it has always felt kind of perverse to me to teach theater to people paying so much money to study it. I love lots of people who teach theater, and I am not calling them perverts, but it was not for me. Though I do love teaching, guest lecturing, etc. particularly at cheap state schools where I don't feel guilty because students aren't paying that much money.
—Meghan Finn

I was an instructor at a paint-and-sip place for five years, pre-COVID. It was fun—the customers were so starstruck that I could paint a straight skinny line effortlessly. I loved being with them, boosting their confidence, saying little things like "Wow! Good job!" It was fun, silly, and allowed me to perform. I

learned that I like to share tips and tricks to make others' work great, and that I can bring out the potential in people who never believed in themselves.

—Maria Camia

I taught a semester-long musical theater writing class at Wesleyan University. The class paired librettists and composers who would work through the semester to create an original, one-act musical. It helped me clarify what I believe and what I value when it comes to creating new work.

—Greg Kotis

When I was in high school, I taught a three-day class on zine-making at the local community college. My psychiatrist set it up for me cuz they were friends with one of the professors there, and let me tell you what a shitshow *that* was. I don't think I'm good at teaching because I recognize that my experience isn't universal and everybody has their own way of doing things, and I don't want to stifle anyone or give the impression that my way is the only way things can be done, so me teaching is just like, "WELL THIS IS WHAT I DO—YOU CAN DO IT TOO, OR FIGURE SOMETHING ELSE OUT. THERE ARE NO RULES. GO PUNCH A COP."

—Anonymous Zinester No. 1

When I did teach, I learned that some people can't be taught.

—Edward Thomas-Herrera

True. I've definitely logged some time being unteachable. Or maybe I was just waiting for a teacher like you.

Taking Classes

I take classes, but I give them back.
—Winter Miller

I've taken some singing classes so I'd stop sounding like I was skinning cats and harmonizing with their cries, but other than that I have not really taken classes. I used to be afraid I wouldn't be good enough to hold my own. Now I would love to.
—Shelton Lindsay

My high school singing teacher was a yeller. Not *Whiplash* bad but fierce enough that I developed a real hang-up about singing publicly.

Thirty years later, I started singing a bit in my variety show. It was scary, but I liked it. Like Shelton, I realized I could pay someone to teach me how to do it better. A free introductory class with a teacher who'd been recommended by an acquaintance convinced me to commit to a three-weekend-long intensive course. These music lessons bore little resemblance to my high school memories of being divided into sopranos and altos and berated for failing to achieve a certain pitch or tempo. This was closer to what group therapy must be like at its best—folks who just met rolling around on the floor with their eyes closed, grunting, yowling, breaking into tears and uncontrollable laughter. We also managed to get some singing in. Those bad feelings that had been gumming up the works since high school dissolved. But there was one student who couldn't, or wouldn't, "go there." Her comfort zone was tightly reinforced against any exercise that challenged her to make unpretty sounds or contort her face into grotesque expressions. Attempts at gentle encouragement and offers to skip her turn, then circle back to give her another chance, were rebuffed. On our second day together, she went out to lunch and

never returned, leaving me to wonder what the refund policy was in such a case. I also, it probably goes without saying, felt more than a bit judgy.

Though, really, who am I to judge?

I've spent years eyeballing cartoonist Lynda Barry's summer classes at the Omega Institute. I love her. She is a patron saint of the small potato. If hers were the only books available to me on the proverbial desert island, I would have no complaints. I have bedazzled teens in my art and writing classes using idiosyncratic exercises lifted from her book *Syllabus: Notes From an Accidental Professor*. Every interview she does reinforces what a kind, attentive, funny, and fun-loving teacher she must be.

So why do I keep finding excuses not to sign up? Well, it might be a pain to get myself to Rheinbeck without a car . . . And I have successfully conditioned myself to think my family will run off the rails without me . . . And her workshops cost more than I'm in the habit of spending on myself, though come *on!* Fans at comic cons spend more having their photos taken with minor cast members of Star Trek spin-offs than this bucket-list splurge would run me, and they walk off happy after thirty seconds! I could bask in the presence of one-of-a-kind and mighty inspiration from Sunday to Friday! Share communal meals with new friends! Hike! Swim! Skinny-dip maybe! If Lynda or I get mowed down crossing the street before I can convince myself to carpe this particular diem, I will be so pissed! Here's an epiphany. How about I skip these self-sabotaging roadblocks and the part where I beat myself up about them? Why not just set some money aside and be prepared to hand it over the next time registration opens.

Now that we've fixed my issues, let's revisit the woman in singing class. To her I would say: Free sample classes are there to hook paying customers by giving them a taste of what they're in for. But the taste is free! If you don't like it, don't commit!

Lynda Barry
PATRON SAINT of SMALL POTATOES

If there's no free-sample option, reach out to the teacher to see if you can pay for the first day of class à la carte, after which you either will or won't commit to the rest of the series. Might be a no, but don't let that automatically scare you off. Arrange for a brief convo to get a feel for what class will entail.

Be honest about who you are before plunking down a nonrefundable deposit. Tell the ballet teacher you feel claustrophobic and undeserving of love when you're sausaged up in 'tards and tights. Remember that it's not their obligation to change the dress code, but maybe they will. Or maybe they will hear past your resistance and understand that your desire to dance is stronger than the cement barriers you've installed as a protective measure.

If they seem warm and encouraging, like someone you could trust when you're feeling vulnerable, maybe you should follow through. It's up to you to do what *you* want. Even if it's something you don't do naturally. Or something you do all the time, meaning you may be more advanced (and set in your ways) than the other participants.

Put it this way: don't *not* do what you want. Don't let hypotheticals, fear of the unknown, and all the little issues and conditions you've scattered in your own path hold you back.

And go easy on yourself if your efforts to improve or stretch yourself in new directions fall somewhat short of miraculous transformation. Keep trying. Keep practicing. Do your homework. Be brave.

The struggle is what teaches you.

—Rob Ackerman

Does watching cat eye makeup tutorials count as continuing education? I'm not above taking classes if they're free, workable with my schedule, and relevant to my interests and needs.

—Liz Mason

Taking Classes on a Student's Budget

My willingness to ante up class fees that might net the teacher something close to a decent hourly wage is a recent development. For a long time I couldn't afford to consider anything that wasn't on par with a movie ticket. I've pounced on many freebies over the years, some of which I remember fondly, particularly a two-hour intro to squatting in New York City and an afternoon spent applying gold leaf to manuscript pages like a medieval monk.

When it comes to free classes of a few hours, the adage about getting what you pay is pretty much bunk. I once hung around a Skillshare classroom, waiting to enter the world of classical Indian dance. After forty-five minutes, when it was becoming pretty clear the teacher was a no-show, another would-be participant offered to lead a hip-hop lesson for those who still remained. Something I would never have circled in a course catalogue that turned out to be a total blast.

I took a three-day workshop called Not Knowing. Its leader set up a series of experiences that the workshop group engaged in with no prior preparation. We traveled across the city of London alone, or sometimes in a group or with one other participant, to experience unfamiliar circumstances and reckon with being in a position of *not knowing*.

—Karen Christopher

I'm in two groups that discuss race, both of which require homework in the form of reading, viewing, and an activity such as journaling or getting folks to vote. I'm also in a group that analyzes Brahms' symphonies with the scores. They are immeasurably helpful in terms of learning other perspectives, honing my critical thinking, and learning various languages of history, politics, and music.

—Nick Balaban

I have a vague notion of maybe one day making a movie. This seems like an impossible dream at the moment, but movies are made by all sorts of people at all stages of life, so who knows? One step toward achieving this goal has been watching Werner Herzog's Masterclass series. He is passionate about the art of cinema, blunt about the industry, and speaks with the authority of long experience. His advice includes reading a lot, walking a lot, learning by doing, starting with shorts, not becoming a creature of the festival circuit, and keeping things formal and professional with your colleagues while on set. Reading and walking I can do. Not yet sure about the other things.

—Greg Kotis

As for myself, I've started groping my way toward that web series I'm always yapping about, taking classes in acting on camera, studio production, field production, editing, lighting on a budget, and shooting on a smartphone—subjects I sincerely hope are now required of all theater students at Big Banana University. The local community access station offers these classes for anywhere from free to twenty-five dollars for eighteen hours of hands-on instruction. It's pleasing and horrifying to think about how much BBU would soak its students for, to learn the exact same thing. I particularly enjoy the company of my fellow students, who are a lot younger, more mainstream, and vastly less white than I am. Layers upon layers of learning.

I also completed a very reasonable online sewing class that met twice weekly and came with a side order of Marxist Labor Theory. The very lively discussion boards where classmates shared book recommendations, sewing tips, and resources for ball fringe and buying Amish underwear meant the education continued well beyond our Zoom classroom.

THE SMALL POTATO MANIFESTO

WE RELISH THE FREEDOM OF OUR RELATIVE SMALLNESS WITHOUT HOPE OF WEALTH. THE ONLY TIME WE GET IT WRONG IS WHEN WE AVOID DOIN' IT. WE CHOOSE WHEN TO BAIL, AREN'T SCARED TO FAIL & CROSS THE FINISH LINE WITH A MIGHTY YAWP. OUR LOINS ARE GIRDED FOR THE LONG HAUL. WE LIFT OTHERS UP & WELCOME SUPPORT FROM ALL QUARTERS. FIE ON THOSE WHO WOULD RATION OUR METAPHORS! OUR GRIT DISTINGUISHES US FROM THE BIG BANANAS. OUR PARTICIPATION FORGES STRONG COMMUNITIES. WE ARE STILL LEARNING.

11. PROMOTING YOUR WORK

Social Media

> Social media is the way I get my community into my shows and my major source
> for finding shows I want to see.
> —Bob Laine

I know a segment of the small potato patch is loath to promote their own work.

Sometimes it's attributable to temperament. Or work that takes such a long time to come together that you don't want or need to constantly remind people to buy what you're selling.

But most of us benefit from an audience. Without a publicist placing full-page ads in the *Times*, it's on us to raise the public's awareness.

I can be a bit of a maniac when it comes to social media promotion. I remember when we had to spend money on stamps, envelopes, and photocopiers to get the word out. The advent of social media shit was like hearing all the candy is free! My DIY promotional methods are pretty artisanal. If that suggests an Instagram feed full of mason jars, sunflower fields, and VW vans trimmed in fairy lights, you're cold and getting colder. It means I spend time making sure every self-promotional post sounds like me. Gotta get that tone right! I'm an enemy of the #SoBlessed school. I'm far happier as a tongue-in-cheek huckster with a wagonful of snake oil to unload. Each post must be funny, self-effacing, appreciative, informative, eccentric, and distinct from the ones preceding it. It's a sign of respect for myself and for the rubes I want to listen to me. This

horror of becoming tiresome, combined with a capacity for magical thinking, makes for some late nights.

It's a giant hamster wheel of my own making. If I run another hundred miles in place before bedtime, two more people may show up to my event, purchase this book, or show interest in my zine!

If I power down and go to sleep? No one shows up. The book's a bust. The zine's a forgettable little nothing that only I care about.

You want to hear a really dirty social media secret? There's a fellow artiste whose posts are an endless variation on "My upcoming show is absolutely unmissable. Buy tickets before it sells out." The infuriating thing is it works! Why? Because while his art (and ego) are pretty heavily invested in passing himself off as just plain folks, he's a big enough banana that the venue pays its publicist to promote him. He's a made man. "#SoBlessed".

Were I to attempt such a feat? The show wouldn't come anywhere close to selling out. Pity those few suckers who heeded me and got stuck with an online advance ticketing surcharge. Everyone else would stay away, put off by my charmless braggadocio. Can't say I'd blame them. I wouldn't even have my foolish pride!

Interns can mimic Mr. Big Banana's voice, but mine is too willfully obscure. It has to come from the hardworking horse's mouth. It only works because I'm also willing, nay, happy to engage on the personal level. I comment. I lavish praise on babies, pets, graduates, gardens, home renovations, vacation views, homemade birthday cakes, and handicrafts. I comfort the sick and grieving. I offer congratulations, even—especially—if it requires me to tamp down some envy. I get so caught up in other people's lives, I forget my self-promotional mission.

If it sounds like someone needs a kitchen timer to regulate the amount of massively time-consuming, hit-or-miss creative energy she spends promoting her creative work, maybe. I could redirect it back onto my actual creative work. If this sounds shockingly close to the Pomodoro Technique, so be it. Somebody needs to impose limits around here!

Use social media to promote your book, your album, your exhibit, your comic, your podcast, your zine, but don't go overboard. Don't be like that anonymous steerage passenger in *Ship of Fools*, who, hearing the distressed cries of the well-heeled German couple, vaults over the railing to rescue their pampered bulldog and drowns. (Spoiler: the bulldog survives, to the great relief of everyone in first class.)

> In addition to being my main promotional thoroughfare, social media allows me to have one-on-one relationships with customers and fans. I've made wonderful connections through Facebook and Instagram by posting my art. You've got to post something every day, and it has to be appropriate for the platform. Some things work better on Facebook, some work better on Instagram. Don't worry about posting things multiple times, just don't post the same thing every day. People flick through things, they don't remember what they've seen and haven't seen, but they'll remember if they see the same thing over and over.
> —Todd Alcott

> When I shift to marketing, I notice a marked decrease in interest in what I am saying on my social media platforms. I try to be good at it, but I often forget hashtags, for instance.
> —Shelton Lindsay

We live in this age for a reason, and I think it's best to use it for what it's worth. I use social media so people know who I am and what I do. I treat it as a place where I can share my own perspective, but also a place where I am my followers' wild friend who believes in aliens and farting. I make space for the imagination, play, and healing. I post in-process stuff, marketing, shows, puppets, my clothing, and pictures and videos of myself.

—Maria Camia

Stay away from it! Don't step into the Zuckerberg trap, or the Dorsey trap, or any of the other traps! I send people emails. *C'est tout.* I am usually involved in projects with other people who are active on social media and I draft off their engagement. I probably would benefit from being better connected in this way, but I find the thought of it too exhausting. If I had to maintain a Twitter presence, for instance, I wouldn't get anything else done

—Anonymous Writer-Performer

I give little updates on the working process and some of the sources that I'm exploring in the months leading up to a tour or performance dates. It's a creative exercise to pull something out of its context, an excavation of what I know about the work and how it might be used to sell itself. Closer to the actual dates, I start posting photos, fragments of text from the show, and words from others who have seen it as a work-in-progress. These don't have to be delivered in standard promotional lingo. There is too much to read that is generalized. You don't need to attract *everyone*. You need to attract those who might come to see your work if you play your cards right.

—Karen Christopher

You could probably dedicate your entire life to figuring out the algorithms of social media promotion. Guess what? There are people who do exactly that! I'm hunching you don't really want to be one of them. Though wouldn't it be nice if there were a chip containing that information? Benevolent elves could implant it in our brains while we sleep. Preferably for free.

Bang Your Own Drum

Don't make the mistake of relying on the host venue and its mailing list to promote your work.
—Karen Christopher

These venues can be understood to include the bookstore where you're giving a reading, the bar where your band is playing, the gallery where your installation will be installed, the theater where your late-night puppet cabaret goes up after the mainstage show, the café where you'll be reciting poetry, and any and every festival on earth . . .

Don't hand the ball off for someone else to drop, even if they've got a hungry marketing intern who's eager to prove themself. Unless you're widely recognized as a queen of that scene, the venue's push to their general mailing list won't have the same impact as the one you yourself make to people with a proven interest in who you are and what you do.

Don't waste too much time on theater bloggers. Hiring a publicist was a promotional tactic I tried that didn't work. She was really expensive and did a pretty terrible job.
—Edward Thomas-Herrera

You have to pay money for a publicist to do a good job. The cheaper the publicist, the worse the publicity. In Small Potatoville, no one gets paid more than the publicist. As for creative promotion, I had a show about dogs and we let the audience bring their dogs. I have done this for two different shows about dogs. People and dogs love it.

—Meghan Finn

The takeaway for those of us scared to spend money we may not have on a "good" publicist?

God spelled backward makes a pretty solid hook.

I'd much rather hang onto my money and play to a full house of squirming, shitting dogs than be informed the *New York Times* isn't interested in sending a reviewer, even after the well-paid publicist sent out two whole press releases and a follow-up email.

Creative promotion is a badge you will do well to earn, because it can't be bought. When I was the receptionist for a news and arts alternative weekly in Chicago, one of my duties was opening the mail. I learned that there's little to be gained from padding your press kit with expensive freebies, save the scorn of those whose attention you're trying to capture. Don't get me wrong, the editorial staff was happy to gorge themselves on logo-iced cookies, paint their living rooms wearing promotional T-shirts, and re-gift everything from messenger bags to deluxe flashlights, but it didn't entice them to write about the senders' projects. Kind of the opposite, actually. They disliked the idea that they could be bought. I never cared if film studios and record labels wasted their money, but I felt bad for small potatoes whose pricey attempts to stand out from the crowd were so misbegotten.

The fans on the receiving end of your direct promotions will have a different take on swag. We love the promise of something extra! A tied-in experience that takes us out of the everyday. An unexpected surprise (to quote Greg Kotis: "Is there any other kind?"). During the Great Depression, movie theaters boosted sales by giving ticket purchasers a complimentary piece of cheap dishware. (They're collectible now.) As part of a performance at the Judson Memorial Church in NYC, I dressed up as an old-timey carnival barker and yelled at people on the street to come see the show. It was great because at no point did I draw a crowd. Everyone just looked for two-and-a-half seconds at me and passed by. New York!

—Emmy Bean

A fellow actor and I dressed as joints and attended the Million Marijuana March to hand out homemade flyers for my play *What's That Buzz*. We seriously underestimated how popular two life-sized joints would be at such an event. We were interviewed for two different documentaries. All day, we were surrounded by folks clamoring for pictures (not so much our flyers unfortunately). The low point was when someone who had clearly overindulged tried to light my costume on fire. It was made of foam and went up quick, though my even quicker thinking fellow joint was able to douse it before anyone got hurt. Promoting work in public is the same as doing outdoor theater. You have to expect the unexpected!

—Bob Laine

When I directed a bare-bones production of Rostand's *The Romantics* with student actors for three weekend performances at a rented theater, I went to the lead critic's office at the *Chicago Tribune* and begged him to watch a rehearsal

and write a review so people would come. He did and they did. I will always be grateful to reviewer Richard Christiansen for that kindness.

—Rob Ackerman

Something I do that works is make one of those black-and-white photocopied one-page zines folded into eight pages that I give away for free—a little free zine *about* my zines and other arty projects, like my podcast. It functions as part business card, part promo. One side has a "menu" of all the zines I have and their prices (I display one of these, framed and in color when I table at fests). The other side has contact info—website, email, electronic payment info, and the like. I devote a little bit of it to itemizing fun things that I like, because then it feels more zine-y and personal. Whenever someone buys a zine from me, I throw one of those in. I have heard from a few people that they did in fact come back for more when they saw info about my other stuff in one of those minis.

—Liz Mason

I promoted a *Melrose Place* parody by cutting a version of *Melrose Place*'s opening credits with my cast, which I distributed on VHS.

—Akin Salawu

When I was a young'un, I left a bunch of copies of my zine at local comic book stores. Nobody knew what to do with them even though they were free. Not a single person picked one up, but goddamnit I tried. I also found some deadstock Monster Energy stickers and gave them out free with every order until I ran out. This generated *hundreds* of dollars in sales in about two days.

—Anonymous Zinester No. 1

Give the people what they want: a gift, something small and weird, that goes where social media cannot.

In with the In Crowd

Crowdfunding is necessary in a country where the arts are so underfunded.
—Meghan Finn

This method of fundraising pairs best with undertakings requiring a major cash infusion up front—recording an album, shooting a short film, putting up a show, self-publishing a comic, or servicing a secondhand van prior to an upcoming tour.

I'll kick in on projects I'm not particularly interested in if the beneficiary has been supportive of my work or is someone who has difficulty mustering up confidence in themselves. My donations are modest, but I enjoy adding an early drop to the bucket. It's similar to attending a wedding. I'm happy to join your fifth-grade classmate, your favorite camp counselor, your former coworker, your fellow traveler, your friendly ex, and your great aunt for this special celebration, and am glad I don't have to do it every month. (Stay tuned for some thoughts on Patreon.) If you've never shown the slightest interest in me or my work, and I'm not particularly keen on your work, I will probably hang onto my money until such time as you are in need of funeral expenses, cancer treatment, or domestic resurrection following a natural disaster or fire (*knock wood*).

I've only done one crowdfunding campaign. It was on Indiegogo for the first run of *Caboose* #7. That issue was long and needed to be perfect-bound as a book. I'm not sure I would do it again because that was many years ago, back

before everybody got jaded and burned-out on crowdfunding. We all get tired and resentful of being harangued for money.

—Liz Mason

I rarely support projects if they're not being developed by people I already know, so I sometimes wonder why we can't just cut out the middleman. But then I think, "If you asked me for fifty dollars, would I give it to you?" Dunno. But send me the link to your Kickstarter and I'm in! It's funny.

—Anonymous Writer-Performer

It's largely about relationships, and understanding that you're not begging—it's a win-win if you do it right. It gives your fans an opportunity to express their generosity. A crowdfunding campaign is a big project in itself and not something to be done casually or passively—it requires just as much focus and energy and planning as a tour, an album release, or a big show.

—Ellia Bisker

Crowdfunding is only valid for things *outside* the scope of your normal ops, imo. This weird mentality shift within the DIY community to using crowdfunding sites to execute a preorder is fucking baffling, especially because then more people are taking more of a slice out of your money to start with, y'know? I don't crowdfund. I just put up a preorder listing a few days before I plan on printing, then use money generated by that to pay for the first print run. Sell first print run. Use first print run to pay for second print run. Rinse, repeat.

—Anonymous Zinester No. 1

Over the course of two campaigns, I raised just over fifteen thousand dollars for *The Fae*, a community TV project I wrote and was showrunner for. It took a

lot of work and a lot of individualized—like truly, not just copy-and-pasting—emails to people, texts to friends, and several community events to help us reach our goal. It was almost as exhausting as the filming, and honestly, more stressful, but as I build the credit sequence for the show, I scroll past all the names of the donors, and it's beautiful. It makes my heart sing every . . . single . . . time. Ultimately, it helped build a community of hundreds of people who are already invested in our art, and that's amazing.

—Shelton Lindsay

Are you prepared to work as hard as Shelton did to fund *The Fae*? Disorganized, spontaneous grasshoppers can hit their crowdfunding goals, but only if they commit to behaving like ants for the duration of the campaign.

Do not over promise! Don't offer too many options! Keep it simple! Updates are useful only if there is something real to update.

—Anonymous Writer-Performer

You have to ask literally everyone you can think of to donate something. You have to thank them publicly unless they ask you not to and you have to push your campaign everyday. No one will pay attention otherwise. You have to swallow your pride and just push.

—Meghan Finn

You have to have a compelling, clear, well-made video that excites people into wanting to contribute. Even if they don't, it'll promote your project.

—Bob Laine

You have to keep promoting it and promoting it. Very few things like that will go viral. I have filmmaker friends who've had great success with crowdfunding

campaigns. It's a minimal expense to offer donors DVDs or downloads of a finished film. Theater artists can offer comp tickets, but that starts to eat away at box office receipts. Think carefully about the perks you're offering donors.

—Edward Thomas-Herrera

Keep in mind that lots of people just want to support your project. Rewards that are symbolic in nature, and/or dovetail with things you're already doing, are great for this. High-level rewards don't necessarily require you to create extra work for yourself—we will name a character after you in our next comic, we will give you an executive producer credit in the program or onscreen, we will invite you onstage with us for the curtain call. . . . It's important to think about what the fulfillment will involve when you're designing your rewards. Will it be burdensome, because now you have to knit hats for fifty people or ship out a lot of heavy packages? Will it commit you to doing projects you wouldn't otherwise be doing, because you've promised to make custom cover videos for songs you now have to learn, even though it takes time away from the project the campaign was designed to support?

—Ellia Bisker

The most popular crowdfunding reward I ever offered required me to write each donor's name in Sharpie on a scrap of brown fabric, to become part of an onstage "dirt" pile in my play *Fawnbook*. We sent donors photos of costumed cast members holding their scrap, and also posted them on social media with a tag and a thank you, which attracted more donations. Yummies all around. I think most donors like to be publicly acknowledged. Whenever a supporter's name was inadvertently raked up during a performance, it felt like an unseen hand was urging us onward.

If people see that you really are working on the thing, they'll be more likely to contribute and less resentful about contributing. The best thing you can do is build up an audience before you start asking for money. You know what that is? Paying your dues.

 —Liz Mason

I think crowds should be funded, crowds have to eat too.

 —Winter Miller

Patreon!

I like the Patreon model. That's more like buying a ticket, to my mind.

 —Anonymous Writer-Performer

Or being a fucking Medici for a bargain-basement price!

I get resentful when people do multiple crowdfunding campaigns too close together. My inner snark attitude starts vibing, "How about making better art that people want to buy to fund your next project? I pay to make my own art. You should pay for yours. Or how about researching how much it'll cost to make your chapbook before you demand it have French flaps made out of vellum? And quit tagging me on your post asking for money. Get a Patreon page and quit asking me for dough."

 —Liz Mason

Much as I like the idea of having lifelong benefactors (like Michelangelo!) I have yet to establish the Patreon that might attract them. I don't trust myself to post sufficient amounts of content. I worry that the digital workload would make me even crankier than those vellum French flaps make Liz Mason.

Emotionally, I see Patreon as a challenging opportunity to "know thyself." The same behaviors that can cause issues in my personal relationships also offer obstacles with Patreon: good self-care and healthy boundaries vs. procrastination, avoidance, and people pleasing. I try to break everything into small, manageable chunks of work time. I'm big on using a timer. I will try and work for twenty-five minutes. If it's something I do not enjoy or find myself avoiding, I'll try to work on it for just five minutes at a time. I never commit to new things on Patreon. I learned this lesson the hard way, as so many people do, by overcommitting and then having to cut back. I have so many ideas and a lot of them are just not always realistic to deliver on Patreon. Now, instead of committing, I do everything as a "test" or "beta" and let supporters know, "I am going to test this out to see if you enjoy it and to see if this work is sustainable to deliver on a regular basis."

—Drew Ackerman

Will you be up for the ongoing work you're honorbound to put into your Patreon if all it gets you is twenty or thirty bucks a month? No. This is not to say it's only worthwhile if you're pulling down whatever you'd make freelancing or waiting tables. Rather, you'll get far more from it if you value your patrons along with their pocketbooks. Take their modest contributions as tokens of faith, and let that inspire you to keep doin' it.

I *get* to make art. It's not forced on me. I stopped treating it like a chore and more like an honor and the highest privilege. Anyone who supports me is a blessing. I love all my supporters more than the amount of money that I get. When I expect nothing, the world is given. When I have expectations, I am sucking through a straw with no opening.

—Maria Camia

Playing Store

We used to sell T-shirts for *Another Lousy Day*. The first time, we made a nice chunk of change. The second time, we were left with three boxes of T-shirts that we ended up giving away to Australians.

—Edward Thomas-Herrera

Merchandise should be fun. Good thing you're not an arena rock god! Imagine how drab life would be if your T-shirts' primary objective was to significantly increase your revenue stream! I love knowing there are a few extremely well-dressed humans stumping for me any time they pull on a Theater of the Apes tank or V-neck.

It costs me nothing since I go the print-on-demand route. In return, I don't gouge our handful of customers by jacking up prices more than a buck or two. If you know how to upload an image, you can make a T-shirt . . . or a beer cozy, a phone case, a yoga mat, a shower curtain using print-on-demand. What a wonderful world where any small potato can play store with a print-on-demand site, and the gloriously easy to master, free to use design site that is Canva (may it never shift to a subscription model or disappear overnight).

If you're really old-school, wash the cigarette funk out of some thrifted T-shirts, and make a stencil using an X-Acto knife and a Priority Mail Envelope.

The live soap opera I am in has merch, which is fun for the large cast and for our audience. I don't think these items fly off the shelves—anything that is not a T-shirt does not seem to sell well—but die-hard fans do pick them up and increase promotion by wearing them.

—Bob Laine

Sometimes the pins, patches, deadstock vending machine stickers, and other merch we stock in our distro do better than the actual zines we sell! It used to make me feel BLEHHHH, but now I just see it as an opportunity to include a free mini zine, to see if I can hook a repeat zine-buying customer with a gentle reminder that we don't just sell stickers and patches, and that our primary mission is all these cool zines. Come for the merch and stay for the zines.

—Anonymous Zinester No. 1

Merch has a role to play in tough times, too. This is one instance where it's okay to not agonize over the ethics of a thirty dollar T-shirt :

My dog, Peeber, died, leaving me with a thousand dollars in final vet bills. I thought about starting a GoFundMe, but I always feel like that's kinda begging for money without giving anything in return. I drew up a T-shirt design and used a print-on-demand site. People who donated actually got something for their money and Peeber's bills were all paid off.

—Ben Snakepit

For the real nitty-gritty on merch, here's our comrade Ellia Bisker, who cut her her teeth as the merch girl for Bindlestiff Family Cirkus's High Heels & Red Noses tour, and now races offstage post-show to set up up the fairy-light-trimmed vintage suitcase from which she peddles CDs and a variety of tie-in goods for her band, Charming Disaster:

> It's important to have an attractive display and your own lighting, to have an array of items at various price points, to have good signage, to have a mobile money transfer app and the ability to accept credit cards. Be organized. Count the bank before and after every night's show, and keep track of what you sold to know what you're running low on in the short term and what's working for the future. If you're part of a duo or larger group, designate one person to dash offstage and sell stuff. Take time to connect. Get people to add their email to the mailing list so you can reach them in the future. Bribe them with a sticker or a button if need be.

Sandwich Board

Is there a particular item you invariably grab first from the clean laundry piled on your bedroom chair? I wear my Theater of the Apes tanks so much, they're a spiritual uniform. I relate to any four-year-old who insists on wearing their Halloween costume to school every day. My shirts make me feel good, as does the title I gave myself, Queen of the Apes. Fuck business casual, know what I'm saying? If Bruce Springsteen were prone to running around in a "Born to Run T-shirt," that'd be a bad look, but any small potato who enjoys festooning themselves in their own merch gets the all clear.

Get it printed in whatever colors make you feel foxiest. Take it on vacation for extra souvenir photo mileage in front of natural wonders and iconic landmarks. Wash it 'til it's as soft as a security blanket.

Wearing our own merch emboldens people to engage with us outside of "working" hours.

—Anonymous Writer-Performer

Wearing my merch makes me feel more authentic to my soul. Plus, it's an excuse to share my Instagram with the people who say, "Wow, cool, dude."

—Maria Camia

I'm happy to represent the bands I'm involved in, and we only design merch that I like. The guy who prints our shirts has actually become a good pal. I've stayed at his house outside of Detroit on more than one occasion while on tour, and have even cooked pancakes in his kitchen. He's been known to print rogue shirts of our designs for his kids :)

—Ellia Bisker

I don't have any wearable merch of my own. It would be pretty cool to have a *Caboose* T-shirt, even if it's really just for me. I should just make a stencil and do it. (Why did this not occur to me until this moment?)

—Liz Mason

There are obvious promotional benefits to wearing our own merch, but there are also alchemical benefits from swaddling ourselves in proof of our projects' existences. It makes us love and want to work on those projects more.

The Magic Bus

Ready to shake things up a bit? Take yourself on tour—reward all your hard work with hard work of another sort. You may not see the world, but rest assured that memories will be made on those eight-hour drives from between college towns. Come home refreshed, and ready to relax.

Oh man, I love touring. I believe in it with an almost religious feeling—it gets me out of my head, off my computer, into the immediacy of experience. And there is no substitute for it when it comes to building an audience, one room at a time. It's exhausting and consuming, and you can't really do anything but that while you're doing it: drive to the place, load in, sound check, do your show, sell merch, load out, find food late at night, sleep, rinse, repeat. You get into a rhythm—by a week in, it's hard to remember what your normal life is even like. You get the kind of compressed intense time you get at summer camp as a kid, where a week contains a month's worth of feelings and experiences. And it's an interesting blend of things that are the same and things that are different. Same: the clothes you wear, the food you eat, the songs you play, your rituals of setting up and breaking down, and packing up the car. Different: every sound system, every room you play, every person you meet, every place you sleep.
—Ellia Bisker

Small potato tours have had me on stage as a poet, a musician, a puppeteer, a singer, a reader, and a storyteller. Sometimes it means playing to no one. In a beautiful old bar in Atlanta, we played a show to the bartender. I wish I hadn't been so uptight about that, and wish I could travel back in time to shed some understanding that what makes a good show is getting up with the fine people you're on tour with and delivering every night.

—Moe Bowstern

Tours are both fun and boring. I think they are worthwhile because they get your work to new audiences and expose you to new places, but they can be lonely in a way. You are a tourist when you are on tour, but also working a lot, so it's not like traveling for fun.

—Meghan Finn

Tours? Love 'em if they're organized well enough to avoid nasty surprises and too much misery, which is a feat.

—Nick Balaban

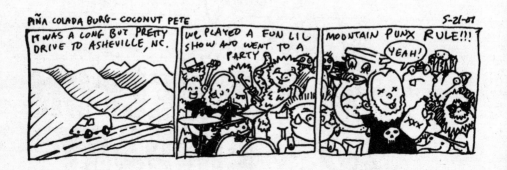

Roger that, Nick. The feat begins at home. If you've never read a punk-rock tour diary, start there. Use it as a litmus test. Small potato tours tend to be much gnarlier than the ones that leave the biggest bananas whining like babies about the hardships of "the road." Are you willing to swap the comforts of home for a certain degree of discomfort, odor, crabbiness, and uncertainty? Are you prepared to practice patience with yourself and others? No shame in deciding it's not for you.

Still chomping on that bit? Great! Start hashing out dates, routes, and accommodations. Gird your loins for a massive promotional undertaking. Go down the rabbit hole, researching areas of extracurricular interest: the bookshops, record stores, thrift shops, cultural attractions, and humble establishments where you can sample a locally famous dish. Go into it accepting that you won't make it to half of the stuff on your fun list, which is fine. Gives you a reason to go back, possibly as part of a lovely, nonworking holiday.

Have good contacts in the area. Reach out to local publications and get that press!!! Let your tourmates take space when they need it, and take space when you need it. Get some sleep.
—Meghan Finn

Bring earplugs!
—Liz Mason

The ole "don't be an asshole" advice is super important for tour. Get out and move your body whenever you can because it will make you kinder on the long drives. Take headphones and a little charger pack, so you don't have to fight over the one available outlet to charge your devices. Pack light—one flashy outfit for the show and one for the van. Don't be weird and bro-y about music—even if

you are the driver, no one is interested in hearing the same playlist more than once. Someone needs to sleep in the van so it doesn't take off without you. Do the occasional group thing, like everyone getting the same stoopid sunglasses from a Nashville corner store—it's cute and good for photos. Be as self-sufficient as possible, foodwise. The very worst tour experience I had was as a musician-puppeteer for a paid gig where we mostly traveled on freeways and nobody had any money except the guy who booked everything. He would only stop at restaurants, ordered whatever he wanted, and never shared, *and* he resented going to grocery stores so the rest of us could get food that was cheap, and nutritious, and conformed to various diet restrictions.

 —Moe Bowstern

Documenting the experience while we're doing it and posting about it from a phone in the car makes me a little carsick, plus the reception can be bad and it always kills my data. Hiring someone to handle the daily social media tour promos back at base camp while we're on the road has been a game changer. I'm someone who turns into a monster when I need to eat, so I make sure there are substantial snacks in my tour cooler—cheese and crackers, apples with almond butter, carrots and hummus, and avocados are all staples. This also saves money, and means we're not at the mercy of gas-station junk, fast food, and the generally terrible timing of eating around the show, which usually means before 5:00 p.m. or after 11:00 p.m.

 —Ellia Bisker

As tempting as it is, unless the next day is a day off, you will kick yourself later if you spend too much time with your admirers after your gig. You need time to safely pack up your equipment, collect your pay, and give your respects to the

staff and booker. Then drive off to get yourself some much needed rest—to the nearest rest highway area, if you're in a vehicle where you can safely and legally sleep. One of my rookie mistakes was thinking I could sleep in my RV outside the venue after my show. Fans kept knocking on my doors and the windows, calling out my name—"Come inside, drinks on us!" There are ways to organize parties for your fans . . . this isn't one of them. It's also not a good idea to travel with someone who doesn't have a healthy understanding of what being on the road entails. Another performer will understand the focus and energy that is required for each show after long hours of driving. Your best friend may not.

—Lorijo Manley

Be a Good Guest

There's another critical difference between your average big banana tour and the low-budget, DIY versions we small potatoes undertake.

I'm not arguing that a luxurious, private motor coach wouldn't feel more cramped than a twelve-thousand-square-foot house with a tennis court and a pool, or that it's impossible

to miss your family while sipping room service champagne atop a thousand threads per inch. Only that couchsurfing is a given on most small potato tours, and you can't behave in someone's home the way one arguably could in a hotel or a commodious, custom-built tour bus. If you aren't prepared to be a good guest, don't bother going on tour. Don't ruin it for the rest of us.

> We make sure we're tidy, quiet, and considerate. We also try to be sociable—entertaining, attentive, and engaged. The importance of being a good houseguest should be obvious, but it's even more so when you're the weird band crashing for the night. We try to make it a good experience for our hosts. This part can be a bit tiring when we don't know our hosts well, and it's sometimes worth springing for a motel to recharge (this advice applies especially to introverts).
> —Ellia Bisker

Crashing with friends and friendly strangers can be wonderful. Other times may find you wishing you'd sprung for that motel room. Whatever the situation, your own manners must remain above reproach.

> You won't know what kind of bed you'll be sleeping on (maybe clean sheets spread on the floor), whose ex you're going to run into (possibly your own!), or the hygiene level of people's bathrooms or kitchens. If you're allergic to animals, you may be out of luck. Some hosts will want to stay up late and visit and it's important to make sure that someone on the tour is willing to do that. You may encounter glaring roommates who send your danger meters through the roof, or spouses in the middle of a mental health crisis that your presence is greatly exacerbating.
> —Moe Bowstern

WE WENT ON WHAT FELT LIKE THE LONGEST DRIVE EVER, CHICAGO TO COLUMBUS.

WE PLAYED A FUN SHOW TO A PACKED HOUSE

WHY IS OUR FIRST TOUR TURNING OUT SO AWESOME? I DON'T GET IT.

THANKFULLY, COLUMBUS KIDS DON'T PARTY VERY HARD, SO I GOT A DECENT NIGHTS SLEEP.

Z Z Z

If the roommates are giving you the stink eye, stay out of their way. Be nice to your host's bratty kids. Do not utter one critical word about their behavior, even if you think their parents won't overhear. Don't expect to be fed, and praise whatever food and drink is offered, even if a big ole hunk of pork prevents you from eating the entrée. Don't get so drunk that you pee on the couch.

I get them a gift that I know they will want—a bottle of something for them and their flatmates, or I take them out to dinner. Whenever possible, I try to deep-clean their house as a thank you. Obviously, I give them comps to the show.

—Shelton Lindsay

Send them a thank you afterwards, even if it's a silly postcard. Also, plug whatever arty thing they do. People are appreciative of other people plugging their work. Leave them copies of your zines.

—Liz Mason

My band had "Charming Disaster slept here" fridge magnets to give to our hosts upon departure. They aren't available for sale—you have to let us stay at your

house to get one. We've done a few series of them now, so there are a couple of folks who have collected more than one. If you happen to see one on someone's fridge it's like a hobo sign: this is a safe place to stay! And of course it's a very exclusive badge of honor.

—Ellia Bisker

The other side of small potato tours is that once you've been on one, you're obligated to host tours or travelers in order to retain imaginary future accommodations. I hosted the first-of-its-kind national zine tour in my tiny one-bedroom apartment on the Lower East Side (the kind where the bathtub in the kitchen has a special metal cover you can use as a table).

—Moe Bowstern

That is some hardcore hospitality! Though here I must offer a dissenting opinion. I *don't* think you're obligated to return the favor in-kind. It's nice, of course, but we're not always in a position to do so. Don't blurt out a blanket invitation to bunk with you next time they're in town if something in you dreads the prospect of your hosts taking you up on it.

My housemate (a.k.a. husband) is not a very social sort of butterfly, and our quarters are cozy enough that even the most considerate guest would have no choice but to invade his sphere . . . a stressful recipe for all parties, including myself. This being the case, one of my responsibilities as a good guest is forcing myself to be clear with my hosts that I'm unable to return their hospitality. I save everyone's face by leaning a bit heavily on our apartment's comparatively dinky dimensions. Maybe I should start telling them my bathtub's in the kitchen.

To be clear, size is not what really matters here. Even if you're set up to offer everyone on tour their own private guest room, make damn sure in advance that no one in your household views this as an imposition. Not that I think it's my tourmate's or my fault that our host's husband asked her for a divorce within minutes of us backing out of their driveway. I do cringe a bit remembering the delicious, homemade breakfast she'd insisted on serving us before we hit the road, and how I, ever the Tigger, not to mention a perfect guest, made sparkling conversation by asking how she and her husband had met.

Table Talk: Festivals

Small potatoes of literary, arty, crafty, or comix-y bent have a unique relationship to tables. We will hump clear across the country to sit behind them, jaws aching from overtaxed smile muscles, our feet wedged against an empty suitcase we'll repack with all the stuff that didn't sell.

A little bit tour, a little bit merch, a little bit hands-on promotion, and a whole lot of work, festival tabling offers a way to participate in our subculture, meet some other practitioners, and lay in lots of stock.

Tabling is *so good*. It's where 80 percent of my total DIY income comes from. Do something creative with your table—figure out what's actually *you*, not just what everybody else is doing and then do that. I should take a picture of my tables cuz my tables usually slap, but I'm always too busy and forget. Bring lots of change!!
—Anonymous Zinester No. 1

It's fun, exhausting, and interesting. Always surprising to see what will make people stop, and more surprising to see what people choose to buy. My advice to those tabling is engage, but don't hover.

—Anonymous Writer-Performer

Tabling can be really fun if you're lucky enough to have interesting people at adjacent tables. I've made lifelong friends through random placement, including one who upgraded into a wife. My best advice is say hello to passersby and appear ready to engage, but try to read body language or language-language. Some people like to chat, while others prefer to browse uninterrupted. I generally acknowledge someone's presence with a friendly greeting and then invite them to pick up or leaf through any comics on the table. If they ask for a recommendation or have a specific question about a comic, I take that as an indication they're okay with chatting. Otherwise, I generally leave them alone to browse without input. Because it keeps me involved, I try to stand the entire time I'm at my table (except when eating, nobody wants to see that). Unless you're a well-known cartoonist, I'd recommend against sitting for long periods, drawing in your sketchbook, or being so engaged in conversation with tablemates that you ignore those on the other side of the table.

—J.T. Yost

Arrive on the early side, so your setup won't feel rushed. Take time to introduce yourself to your future spouse and anyone else who may be tabling on either side of you before the doors are opened to the public. Share your blue painter's tape and Sharpies. Break their big bills. Watch their table so they can take a bathroom break or a spin around the festival floor.

Cartoonist Robyn Jordan and I forged an instantaneous bond when we were assigned adjacent tables and passed the slumpy mid-afternoon hours collaborating on the first couple pages of an exquisite corpse-style comic we titled *Crafthole*. Its main character was a giraffe who grew more and more demoralized watching fest attendees streaming past her carefully arranged display, to throng the table where a carefree spaniel was peddling haphazard lumps of dog doo. It still cracks me up. "The public can't get enough of that shit!" Was it based on real life? Sure! Sometimes you're the giraffe. Sometimes you're the dog.

The public can behave badly—balancing full drinks on virgin comics stacks, passively watching their kids mangle the merch, blocking potential customers' access by casually parking their buttocks on your table's edge as they and their friends discuss where to go for brunch . . .

Bring friends who do magic and have positive vibes, then the people *come on over*!
—Maria Camia

Whoa, is *that* the secret? Duly noted for next time. I actually prefer to table alone, but love it when friends swing by to say hello. After a few minutes of chitchat, I'll offer to stash their coats and backpacks, then send them off to browse unencumbered, thus ensuring I won't indulge in some of the behaviors J.T. cautions against. I count as magic any unexpected gift of coffee or beer that a friend brings to me, but the truest wizard has got to be my pal, Gerbo, who was so outraged by one venue's inadequate lighting situation, he ran home for an extension cord and floor lamp to illuminate my wares. (To be fair, the venue was a black-walled bar, and the sun was setting.)

Hanging out with comic and zine friends I've only corresponded with via mail (as in the old days) or the Internet after tabling is always wonderful, getting

contributors to sign their pages in my comic anthologies. At LA Zine Fest, I saw celebrities shopping the tables, including Matt Groening and David Ury. I had zine friends around to celebrate my birthday at FLUKE Mini-Comics and Zine Festival in Athens, Georgia. Bonding!

—Delaine Derry Green

I love tabling: being surrounded by other zinesters, people who read zines, people who want to talk about zines, going to workshops or leading them, everything about the culture. I would like to go to more, but my schedule does not always allow for it. I can't complain, though. In many ways, working at Quimby's is a zine fest every day.

Do these things *before* you pack up your stuff to make your life as stress-free as possible once you get there:

- If you don't print the price on your zines, make a sign with prices and label everything with price stickers in advance so you're not scrambling to make a sign or look up a forgotten price at a crazy tense moment. Introvert zine-y customers are too nervous to ask prices and unpriced stuff doesn't sell.

- Having information in multiple places is sure to give your audience the freedom to understand what is happening at the table.

- Make a list of what you're bringing and count how many you have left at the end of the day. Mark that down in some kind of spreadsheet. Next year when you table at that same fest (or a similar fest elsewhere), you'll know what things to bring and what not to bring, as well as what things to bring *more* of.

 —Liz Mason

Public Reckoning

In addition to the puppet show wherein I trashed my seventh-grade classmates, I used my third book as an opportunity to tattle on a former coworker's bizarre breach of hygiene. I was in a bookstore, about to give a public reading, when a guy who looked an awful lot like that former coworker walked in. It wasn't too huge a leap to imagine a rifle concealed beneath his coat. Luckily for everyone involved, it was just some random dude. Any time you put yourself on display, whether you're on tour, attending the opening of your group exhibition, or tabling at a festival, you're a sitting duck. Brace yourself. Not for a rifle slug so much as an awkward interaction. In my experience, those are far more common than tense confrontations.

I once drew a fairly detailed comic for Nicole J. Georges' *Bad Roommates* zine about the worst roommates I've ever had. I changed their names but didn't bother to change defining characteristics or actual details of what made them horrible roommates. I reprinted it in one of my comic collections and had it out on my table when two of the former bad roommates, who had, over the years, transformed into a married couple with offspring in tow, happened to attend the comic con and spotted me behind my table. I had not seen them since we'd been roommates over twenty years prior. We engaged in small talk, everyone pretending we'd left on good terms (even though they'd kicked me out a week before the Christmas holidays because my dying cat, paralyzed from the waist down, didn't always get his entire feces inside the litter box). As we caught up, one of them was idly leafing through my comics. I suddenly realized that my comic about them was on the table, so I did some *Three's Company*–level distraction, as I knocked all the offending comics onto the floor behind my table

and kicked them underneath. They were none the wiser, but it did make me reflect on the collateral damage autobio comics can cause.

—J.T. Yost

Grant Applications

I have applied for grants, because I'm fucking poor, but I have no idea what I'm doing, dude. I've only ever gotten one grant, and I think it was some kind of attempt to buy me off so I'd quit bad-mouthing the grant-givers on the Internet, which clearly did not work.

—Anonymous Zinester No.1

I don't apply for grants. If I were a bigger potato, I would, for sure. Partly, I'm lazy, partly I don't think I have a good chance of being awarded those kinds of things, and mostly because I don't make the time.

—Anonymous Writer-Performer

> I have not applied for grants. The complicated process and concerns that my work is not the kind for which they give grants have dissuaded me.
>
> —Bob Laine

In my early twenties, I stumbled on the Foundation Center, a library filled with binders artists could flip through to find out about various grants. I was waiting tables at the time, and a grant struck me as something akin to an enormous tip. I wanted one!

My approach to going after these white whales was optimistic, slipshod, bold, . . . handwritten. I once overheard my roommate telling a mutual friend, "Ayun's trying to get a grant for being herself." I was too impatient to educate myself as to the level of effort, organization, and support materials bagging one would have required. When a former professor refused to recommend me for a grant intended for mid-career artists, I was outraged! In hindsight, I side with her. She would have made a much more appropriate candidate for that grant than my inexperienced, twenty-three-year-old self.

Now, there are plenty of opportunities for emerging artists, as well as artists of color, artists with disabilities, artists making work on queer themes. . . . There are residencies that allow you to bring your little children. These opportunities are easily discovered online, though application requirements and fees seem more daunting now that everything's done digitally. Don't bother uploading a shitty video, especially if the next task requires you to PayPal fifty bucks by 11:59 p.m.

Subscribe to your state's art's foundation newsletter to be alerted to upcoming opportunities. Click the links and bookmark ones that look good, particularly all-expenses paid residencies in European châteaux. Remind yourself that it's a marathon, not a sprint. You don't have to apply for all of them right this second! Of course, by the time you're ready to apply, half of them will have folded up their tents. It's still fun to dream.

Call the foundation, ask questions, get familiar with successful past proposals. If you get rejected, which you will, reach out and ask for feedback on your application and apply again next year. I would say you usually need to get rejected from a program about five times to get one. At the beginning of each year, write your own boilerplate narrative about your work, your artist statement, and your timeline for your upcoming projects. That way you can crank the applications out as fast as possible, and won't spend too much time worrying about them.

—Meghan Finn

Omg, I apply for grants all the time. I never get them, but it's fun to write the artist statements and try to figure out how I can pitch myself.

—Shelton Lindsay

Money is great and cohorts are great communities. When applying, be true to the art before the grant or residency. Do it for your truest and most wildest dreams, not for the title of a residency or a grant. Authentic mad-scientist artist vibes are what really shine in their eyes.

—Maria Camia

I apply, but I rarely get them. I am not surprised. That's what happens when your work appeals to a specific niche. Or I'm just a shitty grant application writer. I know it helps to write an artist CV and an artist statement that you can reuse and update every time you do a new project. I was once told in a grant-writing workshop that you should make it clear that you plan to do the project even if you don't get the funding. If you can convince the grant committee of that, you're more likely to get the funding.

—Liz Mason

I LOATHE THE IDEA OF GRANTS, HAVING TO DO ALL THIS FREE LABOR TO COMPETE WITH OTHER ARTISTS FOR A LIMITED POOL OF RESOURCES TO CONSTRUCT ART PALATABLE ENOUGH TO BE MONETIZED. IT'S VISCERAL & ALSO WEIRD BECAUSE I DO _SO_ _MUCH_ ART FOR **FREE!** WHY CAN'T WE JUST GET $$$ TO DO THE _GOOD_ WORK WE'RE ARE _ALREADY_ _DOING_!?

...I'M NOT MADE FOR THIS WORLD.

MOE BOWSTERN

Clearly, our world is in need of more low-key funding opportunities. What if we let it be known that our final wish is for our families to create an annual microgrant with minimal application requirements and no fee, to be awarded to one or more small potatoes who embody our quirky, creative spirit? Not that I'm in a rush to hit the grave, but wouldn't it be fun to see who the recipients are?

THE SMALL POTATO MANIFESTO

WE RELISH THE FREEDOM OF OUR RELATIVE
SMALLNESS WITHOUT HOPE OF WEALTH.
THE ONLY TIME WE GET IT WRONG IS WHEN
WE AVOID DOIN' IT. WE CHOOSE WHEN TO BAIL,
AREN'T SCARED TO FAIL & CROSS THE FINISH
LINE WITH A MIGHTY YAWP. OUR LOINS ARE
GIRDED FOR THE LONG HAUL. WE LIFT
OTHERS UP & WELCOME SUPPORT FROM
ALL QUARTERS. FIE ON THOSE WHO WOULD
RATION OUR METAPHORS! OUR GRIT
DISTINGUISHES US FROM THE BIG
BANANAS. OUR PARTICIPATION FORGES
STRONG COMMUNITIES. WE ARE STILL
LEARNING. WE WILL STRIVE TO GET THE
WORD OUT

12. YOUR WORK FOR POSTERITY

Make Copies

Do the future a favor.

Preserve your work.

Document your work.

Omg, I've done like five million shows, but I only learned how to film and edit my own work after COVID started. *Wow*. If I had done this five years ago, I would have such an impressive catalogue of work.

—Shelton Lindsay

Do the future a favor.

Preserve your work.

Document your work.

Archive your work in such a way that you won't lose everything should your home (*knock wood*) burn to its foundation while everyone's out supporting another small potato's creative efforts.

I wish I could say I am great in this department, but sadly, no truth could be more partial.

Whenever a new issue of my zine comes back from the printer's, I lay aside three copies. One for me and one for each of my kids. (They can recycle 'em along with their autographed copies of my books after I'm dead.) Back when I had some regular column

I'd save the magazines in which they appeared. When it was time to move after sixteen years in one spot, I ripped out my columns and left the rest.

I always keep my zines' master copies, both physically and digitally, making sure to back up my computer periodically. Any work I've done, performances, places that have published my work, interviews I've given or media I've gotten, I list on an updated CV on my website. I always try to get a contributor copy of the thing I contributed to, even if I have to buy it.
—Liz Mason

Of my onstage work, barely a whisper remains. There are crumpled scripts and programs but scant video evidence. The few things I did manage to record show little blown-out with tinny voices moving around in front of a row of deserted folding chairs and a person with a very prominent head. I pray that these videos are an inaccurate reflection of the real thing.

Videos suck at capturing the energy of live theater and nobody wants to watch them. I wish I hadn't spent so much energy getting stuff on video.
—Edward Thomas-Herrera

I have been pretty good about documenting everything lately. When I was young and it was harder than it is now, I didn't really do it well. Now, I hire a friend to do it. She is great.
—Meghan Finn

Many of the shows I have been in have been recorded for the participants' eyes only, usually because some of the performers are in Actors' Equity, which prevents us from sharing the full thing on YouTube, our websites, or social media.
—Bob Laine

Invest in a professional videographer. Friends are great, but people who get paid and have deadlines will get the job done sooner.

—Anonymous Writer-Performer

If one of your primary objectives is a three- to five-minute representative work sample for grant applications, take whatever measures are necessary to ensure your video will look and sound better than Grandma's attempt to capture commencement from the eleventh row.

When appearing under someone else's auspices, find out if the presenter or venue has plans to tape. If the answer is yes, ask for a copy. Note that this is not a foolproof plan, even when the venue's pockets are comparatively deep. I expected footage from an hour-long reading and studio interview recorded as part of an upstate college's Distinguished Visiting Author (!!!) Series would prove extremely useful going forward. Unfortunately, the kid subbing in for the sophomore who usually operated their broadcast-quality equipment didn't review the equipment checklist ahead of time. At the end of my hour, he went to check playback and saw nothing but snow. Always hit Record. Always check the SIM card. And don't count on someone who's not on your nickel to get the goods in the can. Honestly, I get even more scattered than usual thinking about how to best store all this stuff. My number one preference would be an old-fashioned milk can in a location my descendants and I will have access to forever. But then I think about the fate of the time capsule my fifth-grade class buried in the principal's yard. I used to imagine sneaking over there in the dead of night with some of my old crew with a bouquet of shovels and a bottle of booze. But before we could get around to realizing this fantasy, the principal's house was sold and demolished, as was the hill containing our capsule. Sort of like how formats, equipment, and operating systems become obsolete. Just do your best. Ask a fellow small potato who seems like they've got this aspect under control to walk you

through their process, step-by-step. Don't let your sweet, soon-to-be ex-wife board a train with a suitcase containing your novel-in-progress and all your carbon copies.

Don't forget our friend, the little notebook! Very handy for jotting down locations, passwords, and the like.

Also, bear in mind that while diamonds (and plastic) are forever, web content is not. Make PDFs and screenshots. Grab an app to rip an MP3 or MP4 off of YouTube.

I was hired by Detour apps to do a voiceover for a GPS-guided tour about Nelson Algren and Simone de Beauvoir's life in Wicker Park. I loved the whole process. And the tour was so, so great when it was all done. You'd download the app and the tour, and the narration would kick in each time you hit the spot it led you to. You'd walk around to different bars in the area, learning all about Chicago culture. It was only up for a year or two and then Detour got bought out by Bose, who took down all the tours. It breaks my heart that I never got an audio file of that tour. It was beautifully scripted, soundscaped, and edited so fabulously. Now it is gone forever and there's not even a working URL to the tour anywhere on the web. I can't prove I actually did it because there's no record.

—Liz Mason

Historical Society

Remember how others' responses to our work provide yummies worth squirreling away? There's anthropological interest worth saving in other types of outside responses, like the semi-shitty *Maximum Rocknroll* write-ups my autobiographical zine attracted back in the day, when my children were young and after a proliferation of "mommy blogs" induced McCarthy-era levels of panic in some of *Maximum Rocknroll*'s young, male reviewers whose punk-rock street cred could be revoked at any time. And by some, I mean young

punks who were still holding Mommy's hand to cross the street, back when I, lactating in an old-school East Village rathole, was a staple of *Maximum Rocknroll*'s top-ten list.

Not to sound like Miss Havisham, mooning over yellowing evidence of my zinely beginnings, but I've preserved some evidence in a three-ring binder—lots of yummies and a handful of anthropological unyummies. I gave myself permission to wad up the most maddening critiques, though I bet a choice few could be truffled back up online, should I ever care to look. Speaking of which, if you're looking for some small potato review publication that slipped below the surface in the early aughts, get in touch. It may be part of my archive.

Makes a nice time capsule. At this point, its contents feel almost as antique as those cassettes and Polaroids my fifth-grade class stowed away for citizens of the future.

I heartily suggest you start—or add to—one of your own.

You can goose things in that direction by enlisting an outside party to provide some material.

I have commissioned people to write about my work.
—Karen Christopher

What a coincidence! I was once commissioned to create a zine documenting a panel discussion on intimacy and art. The event was poorly attended, which seemed surprising, given that a live, participatory sex workshop was scheduled for after the lunch break. Perhaps the organizer had run herself so ragged getting everything set up, she underestimated the amount of time she needed to spend on promotions. Or maybe it's just impossible to get folks to show up at an East Village black box on a weekday morning.

Either way, she was smart to arrange for documentation in advance, rather than waiting to see if the local rags intended to send anybody by.

On nights when ticket sales are as light as brioche, I invite my artist and cartoonist friends to live sketch my Off-off-Broadway plays. They get free tickets. I get JPEGs of the originals with the understanding that I'll credit them when I reproduce their work on social media in an attempt to whip up interest.

As a youngster, I dreamed that Al Hirschfeld, the King of Broadway Caricatures, would capture my likeness, secreting his daughter's name—Nina—in the creases of my opera-length gloves. Sadly, it was not to be, even though he hung on to the ripe old age of one hundred.

But I have something equally valuable, compliments of Bryce Edwards, a teenage audience member who was lured to a show of mine on a night when we pledged to keep the house lights halfway up for anyone who wanted to draw the proceedings. He ripped it out of his sketchbook and gave it to me for keeps. It's one of the most treasured pieces of art in my collection. It's framed and hanging in a spot where I'm sure to see it many times a day. I don't need a Nina.

LIKE

DEER
IS TRYING
TO DO
THUMBS UP

I ♡ BUCKET

BUCKETS
OF
BUCKETS
OF
BARLEY

HELLO?

Bryce Edwards

Archives

We small potatoes love us some libraries. And not just ones dedicated to print media. Music libraries, film and image archives, museums with special rooms for researchers . . . I'm a sucker for any institution that exists to categorize, store, and maintain information for posterity and public edification.

We can get our work into those institutions, though doing so usually takes a bit of effort and some chutzpah.

According to Chuck Close, the late mail artist Ray Johnson mailed photocopied collages to MoMA, care of librarian Clive Phillpot, knowing he obsessively documented and saved everything that came his way. Because Phillpot logged them in, MoMA catalogued Johnson's collages as donations to the collection. Slick!

Alas, that scam was killed off by the Internet, but we can channel a bit of Ray's cheek by reaching out to librarians and curators to see if they'd entertain a donation of our work. If you're feeling your oats, leap ahead a few squares by sending a small sample as if they'd asked for it. Include a nice letter saying what an honor it would be to have your stuff become part of their collection. The person on the receiving end may choose to archive your contribution in a trash can, but nothing ventured, nothing gained.

I am in the unique position of working for a bookstore that fulfills zine acquisition orders for libraries. When we fill orders for institutions, I can suggest my own work. Does anybody actually look at my work when they're in those archives? I have no idea! I do get a kick at looking up my zine in online library databases I know I'm catalogued in to see how they classify it. "Really? *Awesome Things #2* is listed as 'Joy—Miscellanea and Conduct of life'—*Miscellanea?!* Fascinating!" I enjoy knowing that it's possible someone could stumble on my work in that

MOST HAVE
TAPED SPINES —

LIKE ALL ARTISTS, I'VE FILLED COUNT-
LESS SKETCHBOOKS · BUT MOVE ON
TO THE NEXT ONE W/O REFLECTION.
ONLY NOW, THANKS 2 "QUARANTINE" AM
I FINALLY ORGANIZING THIS WORLD.

setting, and I might possibly gain a reader I wouldn't have had otherwise. And it lets me live out the fantasy that I'm some sort of scholar, which exists in the same place in my brain that also believes I am somehow a media critic because I write about how much I love *Doctor Who*.

—Liz Mason

I'm archived all over the place and so is work I've produced for other people. Usually it happens without us even noticing, which is awesome. Generally it's been good—there have been a few instances of misgendering or misrepresentation of what we thought the authorial/artistic intent was, but I realize people all have their different takes on a work. I can't really police how people want to classify my work when it's difficult even for me to classify in the first place.

—Anonymous Zinester No. 1

Jumpstart a little Swedish Death Cleaning (look it up!) by forging a Johnson-Phillpot friendship with a librarian, archivist, or curator. Save yourself from renting a storage space! Save your children the heartbreaking hassle of deciding what to do with years of accumulated ephemera! All it takes is a library, archive, university, or museum willing to accept it all—flyers, programs, doodles, correspondence . . .

I will die more peacefully knowing my legacy isn't exclusively my children's problem. I'm not sure if I'll ever make it to Duke University's Sallie Bingham Center for Women's History and Culture, but twenty years' worth of my stuff has, with more on the way. Maybe someday, some young researcher will stumble across a scrap of my creative life and think to themself, "Hmm, there may be a seed of something for me in this." It pleases me to think this along with the Small Potato Microgrant, even though I won't be here to see either happen.

THE SMALL POTATO MANIFESTO

WE RELISH THE FREEDOM OF OUR RELATIVE SMALLNESS WITHOUT HOPE OF WEALTH. THE ONLY TIME WE GET IT WRONG IS WHEN WE AVOID DOIN' IT. WE CHOOSE WHEN TO BAIL, AREN'T SCARED TO FAIL & CROSS THE FINISH LINE WITH A MIGHTY YAWP. OUR LOINS ARE GIRDED FOR THE LONG HAUL. WE LIFT OTHERS UP & WELCOME SUPPORT FROM ALL QUARTERS. FIE ON THOSE WHO WOULD RATION OUR METAPHORS! OUR GRIT DISTINGUISHES US FROM THE BIG BANANAS. OUR PARTICIPATION FORGES STRONG COMMUNITIES. WE ARE STILL LEARNING. WE WILL STRIVE TO GET THE WORD OUT. OUR WORK BELONGS TO THE AGES.

13. MANIFESTO TO MOVEMENT

In an ideal world, all of the small potatoes would get in a pot (not a boiling one, thank you) and be one stew, part of one thing. The small potatoes, working together, would become a large, estimable thing that the world would notice. The insistence on being independent scarcely raises any of us beyond the level of individuals. My "theater company" has always been me. "Me" has so far not become a New York City tourist destination. A mega-company of fifty people like me would be a thing to be reckoned with.

—Trav S.D.

A s friend-to-the-small-potato Arlo Guthrie observed in *Alice's Restaurant*, the actions of one or two don't seem so inconsequential once they've been joined by a third. A few more, and people will think it's a Movement!

I abhor the quality of being intentionally blind to the work of others, of making your work in an imagined vacuum, of operating from a scarcity mindset where one success eclipses another or makes another's success impossible.

—Emmy Bean

What happens if we small potatoes make a deliberate choice to pull for each other?

Plug each other's projects . . .

Plump each other up . . .

Pay it forward and back, as an investment in the greater tater good?

Our Manifesto can become a Movement. All for one and one for all.

Invite us to participate in salons and fundraisers where we can showcase our work. Come to our shows and then review them on social media, encourage your friends to see them, etc.

—Bob Laine

Distro our zines. Buy our zines instead of waiting for a free one because you're our friend. Investigate the media we mention in our zines—you telling us you like the thing we exposed you to is our love language.

—Liz Mason

Cross-promote. Mention our names and what we're about, and what we're up to whenever possible.

—Nick Balaban

Share the media that we've made online, and then send it directly to like six friends, saying, "Hey, you should know about these people!" *Word of mouth, baby.*

—Shelton Lindsay

Introduce us to influential people who would produce our kind of theater. I think they're out there.

—Edward Thomas-Herrera

Submit our titles to libraries and institutions for archiving. Instead of just directing people to a handle, drop actual links to our web stores—that makes a huge difference!

—Anonymous Zinester No 1.

Wear our merch on your travels.

Commission us to paint your pets, perform in your living room, write and record love songs celebrating you and your significant other.

Think of a friend who'd dig what we're doing, and surprise them with tickets, a download code, a T-shirt, the first comic in the series, a one-of-a-kind piece, a gift certificate, one-on-one lessons, or an autographed copy from our back catalogue. No need to wait for a special occasion.

Let us know if there's a grant or residency we should be applying for.

Let your friends in other cities know when our tour is headed their way.

Don't forget the yummies.

Hide in a lamp dressed like a genie.

⑭. PARTING GIFTS

I have a bunch of ideas that I won't ever follow through on. I guess that is okay.
　　—Drew Ackerman

Me too. Here's one:

Illustrate the first four paragraphs of John Steinbeck's *Cannery Row*, Chapter Five, at the rate of one sentence or phrase per day.

I still have the mostly blank book in which I attempted this. Unfortunately, I stalled out somewhere around the seventh sentence. That was years ago. With all due respect to Neil Gaiman, I concede! I'll never see this idea through. Take it, it's yours. Some of the small potatoes whose observations and advice grace these pages are also clamoring to make a donation on your behalf.

You're under no obligation to accept their gifts, but if you find one you'd like to take a crack at, don't be shy. Get it! Be the feral trick-or-treater who helps themselves to a whole fistful! We may be small but we're not stingy.

Just don't go saying someone stole your idea if you're not the sole small potato to lay claim to a particular assignment. We're releasing these ideas as loaves and fishes for everyone to enjoy.

We're dying to see what you do with them.

CLOSE YOUR EYES & RUB YOUR BUTT WHILE STANDING TO GENERATE YOUR IMAGINATION. PUT HANDS ON ♥ WHEN BUNS ARE TOASTY. IMAGINE A THRILLED AUDIENCE GIVING YOU A STANDING OVATION. BEGIN TO BOW WHILE REPEATING **THANK YOU, THANK YOU!**

PRACTICE DAILY FOR AMAZING RESULTS IN EXTERNAL REALITY.

MARIA CAMIA

Take photos of men holding their wives' purses outside restrooms at state parks. (Pursue your own relationship to the binary when defining "men" and "wives".) I like the way some people are super casual, while others hold the purses away from themselves as if they might be infected.

—Moe Bowstern

Stage famous naval battles in public pools using rafts, canoes, or other floatation devices. Mock naval battles in flooded arenas like the Colosseum in Ancient Rome and nineteenth-century New York's Bowery Theatre were the action films of their day. Recreate the Battle of Trafalgar using red inner tubes for the British and blue inner tubes for the French. Or perhaps you could conjure the Battle of Midway using dinghies and drones—anything that can fit in a public pool to be viewed by an audience.

—Greg Kotis

Make a one-page comic about something that happened in your life this past week.

—MariNaomi

Retell Rumpelstiltskin thusly: The queen makes the same deal as before, but instead of sitting around and pining about what the guy's name might be, she gets off her throne and investigates. She finds out everything she can about her mysterious benefactor, and, through her investigation, comes to realize that here is a man, disfigured from birth, who has the talent to literally turn straw into gold, but lives in a hut in the middle of the woods. She comes to the realization that gold means nothing to the little man, he wants only to love and be loved by another living thing. Her father sold her to the king on false pretenses, and the king only values the gold she can provide. The little man is not her enemy. In

the end, she leaves the castle and goes to live with Rumpelstiltskin and they raise the child together.

—Todd Alcott

Compose a performance to be watched through hotel room door peepholes. Each audience member occupies a room without opening the door to the hallway, to observe the actions taking place in the hallway via the peephole.

—Karen Christopher

Watch all of Nicolas Cage's movies and then write an epic critical review zine of the Nic Cage cinematic universe. I got like halfway through his filmography—he's been in like ninety-four? Ninety-five???—but had to give up for mental health. Somebody please do this for me so I can read it.

—Anonymous Zinester No. 1

Here are two bands you could start. The first is Wax Lips, a punk rock band with songs about domestic life, such as "Rats Ate My Mint" and "Don't Take the Baby Outside." The other is Spaceface. Spaceface plays electronic instrumental covers of Charming Disaster's (my band) murder ballads and love songs. Perform incognito in silver unitards that cover your faces.

—Ellia Bisker

Document yourself staging increasingly elaborate stunt falls down the steps of public landmarks.

—Stephanie Summerville

Make colorful, cheery yard and window signs reading "Hate has a home here because my neighbors kicked it out" or "because it has to live somewhere" or

"and it pays its rent on time." Sell 'em for a buck and proceeds go to, oh, I don't know, the ACLU? SPLC?

　　—Anonymous Writer-Performer

Write an opera libretto adaptation of Rumer Godden's *Black Narcissus*. Yes, yes, I know there's been a recent TV version and I'm a huge fan of the 1947 Powell-Pressburger film, but I really think the story would be well-suited for the opera. All those great women's roles! All that suppressed sexuality! A critique of colonialism! Just think!

　　—Edward Thomas-Herrera

Take every shitty "Careless Whisper"-y sax solo from all the '80s songs, make a montage of them and then perform them all a cappella for a captive audience.

　　—Liz Mason

A root vegetable called the tiger nut that's native to North Africa can be whipped into a yummy and nutritious nondairy milkshake that's popular in Spain. Can someone open a gathering place in an American city that celebrates and elevates this? You could call it Horchatería Neoyorquina. I would show up.

　　—Rob Ackerman

Paint portraits and paintings for people as a way to celebrate them. Find images that remind you of who they are and paint them into existence. Make it a beautiful meditation, more about time than perfection.

　　—Shelton Lindsay

Film a fifteen-minute version of *King Lear* with one performer playing all parts except the title role, which should be played by a dog. Manipulate the dog's image to make it look like it's talking. A human can dub its lines. I still laugh

at the idea of my late boxer, Linus, begging for a treat while nobly exclaiming "question not the need."

—Heather Riordan

Start a dating service for heteronormative people at their sexual peaks. Without actually looking it up, I think that's eighteen-years-old for men, thirty-years-old for women? Call it "Twin Peaks."

—J.T. Yost

Make catchy restaurant jingles for local restaurants that need a lift. Teach them to people as a sing-along. The media is all decentralized and different than it used to be when anyone could sing the theme song for their local department store, produce market, tire shop, or furniture store because they'd heard it so much on TV. Wouldn't it be cool if that could be a phenomenon that exists in this new world?

—Emmy Bean

Write a comedy screenplay in which President George W. Bush and Tony Blair find themselves crash-landed in Yapland, completely alone and without resources or money (while their doubles run their respective governments). A buddy movie in which the two leaders end up shedding their political masks, depending on each other, hating each other, then ultimately, cooperating in order to survive while learning to love each other and undergoing profound developmental growth. Nutty!

—Nick Balaban

Create a 4D holographic globe of the earth, a research tool that will allow users to access a geographical picture of the world at any time of their choosing, dating

all the way back to the original cooling of the earth. Coordinate it to show the known proliferation of biological species, climate patterns, human migration, shifting borders, animations of troop movements, and things like that. I honestly think all of the technology is in place for such an invention. It will just require a big investment of time, research, and multiple millions of dollars. All I know is that I want and need such a machine in my work *constantly*.

 —Trav S.D.

Since every story has two sides to it, split an audience into two groups. Each group is assigned a different lead character to follow and the only dialogue or internal monologues they hear is that of their assigned character through headsets. This piece can be immersive or traditionally staged.

 —Christine Schisano

Instead of the regular "Things I Want to Do Before I Die," make a zine based on "Things I've Already Done Before I Die." (Hit me up if you need submissions. I have five just sitting in an email folder from 2008.)

 —Delaine Derry Green

Cover the floor with honey and sugar. Do a backbend in it. Allow it to crystallize into candied glass shards of body armor. Let the animals that love you best lick you free.

 —J. Gonzalez-Blitz

Film an adaptation of my unpublished, nay, unwritten novel, *What Ducks Do*, about a group of AIDS patients in Australia who rob banks in duck masks to pay for their meds. Do not wait for me to write the novel. Maybe you can write the novel, too.

 —Bob Laine

Wait! One more from me, because I've always sucked at letting go, and this may well be my only chance to create some overlap with *Star Wars*: Shoot an unauthorized *Star Wars* sequel or prequel on a hidden wildlife cam, using officially authorized costumes purchased at a deep discount the day after Halloween. Bonus points for shooting the entire thing on a neighbor's wildlife cam without their knowledge.

ABOUT THE AUTHOR

Ayun Halliday is the Chief Primatologist of the long-running, award-winning zine, *The East Village Inky*, and a cofounder of Theater of the Apes. She is the author of seven books, not including this one or the one she's writing next. She created and hosts the ongoing Off-off-Broadway variety show, *Necromancers of the Public Domain*. Ayun lives in New York City with her husband, playwright Greg Kotis.

ayunhalliday.com

Contributing Comrades ♡

Anonymous Funnyperson is a comedic actor, creator, and improv coach who also works as a standardized patient. He is the cocreator of an ongoing live painting web series that raises money for the Leukemia & Lymphoma Society.

Anonymous Zinester No. 1 is a zine veteran and cranky as hell.

Anonymous Zinester No. 2 has been creating zines since 2012 and is currently at work on a book about personal finance.

Anonymous Writer-Perfomer is a thirty-five-year veteran of Chicago's fringe theater community, currently a member of a director-less theater ensemble and a former contributor to a long-running late-night show in town. Performing credits run the gamut from low-budget productions of Shakespeare plays to low-budget productions of off-beat original scripts to a failed stint as a stand-up comedian. The writing is mostly creative nonfiction intended for presentation to a live audience. While anonymous for the purposes of this book, Anonymous Writer-Performer does have a name, one you can probably figure out if the mystery is too much for you.

Drew Ackerman is the creator and host of *Sleep With Me*, a one-of-a-kind bedtime storytelling podcast. Born out of Drew's childhood insomnia, *Sleep With Me* was inspired by late-night comedy radio, which was the only thing that helped him fall asleep. Drew's stories on the show are inspired by his childhood as the oldest of six children and past jobs as a fuzzy dice and iron-on patch salesperson, fruit fly monitor for the State of California, and librarian for one of the largest jails in the country. Through *Sleep With Me*, Drew has dedicated himself to helping those who feel alone in the deep dark night and just need someone to tell them a bedtime story.

sleepwithmepodcast.com

@dearestscooter

Rob Ackerman is a playwright whose work includes *Dropping Gumballs on Luke Wilson*, *Tabletop*, *Origin of the Species*, *Volleygirls*, *Teach for America*, *Call Me Waldo*, and *Disconnect*. He is married to novelist Carol Weston.

Nick Balaban is a Brooklyn-based singer-songwriter. He's written music for many kids TV shows, from *Blue's Clues* to *Bubble Guppies*, and has worked, recorded, and/or played with myriad luminaries from Ray Charles to David Murray. His newest album, *Hello, Cruel World!* was released in early 2021.

nickbalaban.com

Todd Alcott is a screenwriter and graphic artist living in southern California. A million years ago he was a playwright and performance artist.

He wrote the play *One Neck* and cowrote the animated movie *Antz*. More recently he has made graphics for Elvis Costello and They Might Be Giants. He has three cats and two dogs.

Emmy Bean is a singer, musician, and performance-maker whose many creative endeavors include *As We Go* (an evolving site-specific performance project), Theater Oobleck's *Baudelaire in a Box*, the bands 80 Foots and Ida May, as well as free Opera-Matic performances in Chicago parks and Escargatoire (klezmer and chamber folk at a snail's pace). She's a teaching artist at Snow City Arts.

beansome.com
@mmybean

Ellia Bisker is an award-winning songwriter, singer, and musician based in Brooklyn, NY. Her musical projects include goth-folk duo Charming Disaster, solo-ish project Sweet Soubrette, and postapocalyptic brass-punk ensemble Funkrust Brass Band. She is a longtime contributor to literary performance series Bushwick Book Club and *Necromancers of the Public Domain*, and is a core staff member of the Bindlestiff Family Cirkus.

elliabisker.com
@charmingdisasterband
@sweetsoubrette
@funkrustbrassband

Moe Bowstern lives on unceded lands at the confluence of the Willamette and Columbia Rivers, where she writes about her experiences as a person of Earth. She makes zines and creates ritual for moving through the year. She writes for the documentary podcast *It Did Happen Here* and a nightly Instagram post, Good Night People of Earth. She is a friend to animals.

Rachel Kramer Bussel is an erotic writing instructor and consultant. She's edited over seventy anthologies including *The Big Book of Orgasms*, *Come Again: Sex Toy Erotica*, *Cheeky Spanking Stories*, and the Best Women's Erotica of the Year series. Her freelance beat includes books, dating, pop culture, feminism, body image, and hoarding.

EroticaWriting101.com

rachelkramerbussel.com
@rachelkramerbussel
@raquelita

Sabrina Chap is a songwriter/performer/writer. Her albums include *Oompa!* and *We Are the Parade. Ms. Magazine* called her latest, *Postcards from the Rearview Mirror* a powerful examination of lust, obsession, and the queer coming-of-age experience." She wrote the music and lyrics for the musical *Fashion Academy* and edited a Lambda-nominated anthology, *Live Through This: On Creativity & Self-Destruction.*
sabrinachap.com

Karen Christopher is a collaborative performance-maker, performer, and teacher based in the U.K. Her practice includes listening for the unnoticed, the almost invisible, and the very quiet. Her company, Haranczak/Navarre Performance Projects, is devoted to collaborative processes, and paying attention as an act of social cooperation. She was a member of the Chicago-based Goat Island performance group for twenty years until the group disbanded in 2009.
karenchristopher.co.uk

Delaine Derry Green is a visual artist with a BFA who counts comics, zines, painting, graphic design, and memes in her repertoire. Her autobiographical comic-zines *My Small Diary* and *Not My Small Diary* have been on the scene since 1993 and have appeared in several museum shows.
mysmallwebpage.com
@humanpanther

Meghan Finn is a director and the artistic director of The Tank. Her work has been seen at the Tank, the V&A, Serpentine Galleries, The Wexner Center, SCAD, The Logan Center for the Arts, Museo Jumex Mexico City, The Power Plant, Canadian Stage, Carnegie Mellon, Brooklyn College, MIT, the Great Plains Theater Conference and others.
thetanknyc.org

Connie Fu is the creator of the puppet show *Nautilus Free Lossy* and is currently at work on a weaving series.
connie-fu.com
@theempress_con

J. Gonzalez-Blitz is an artist whose comics have appeared in *World War 3 Illustrated*, *Not My Small Diary*, and the *Drawing Power* comics anthology. She was the one with the knife in the band Mz. Pakman.

jgonzalezblitz.com

@jgonzalezblitz

Greg Kotis is the author of many plays and musicals including *Urinetown*, for which he won an Obie and two Tony™ Awards, *I Am Nobody*, *The Truth About Santa*, *The Sting* (Lyrics), *Lunchtime*, *Give the People What They Want*, *Michael von Siebenburg Melts Through the Floorboards*, *Yeast Nation*, *Pig Farm*, *Eat the Taste*, and *Jobey and Katherine*. Greg cofounded Theater of The Apes with his wife, Ayun Halliday.

gregkotis.com

Bob Laine is the author of *What's that Buzz?* and performs in the monthly live serial *It's Getting Tired Mildred*. His most recent project is the one-man show, *Inventions*.

madkingbob.wixsite.com/mysite

@madkingbob

Shelton Lindsay is a creative director and designer who works with The New York Neo-Futurists, The House of Yes, Fou Fou Ha, The Lower East Side Pickle Day Festival (serving as their mascot, Mr. Pickle), and others. Called "endearing" by the *New York Times,* he loves to bring imaginative stories to life through performance, costumes, production design, scripting, and direction.

Sheltonlindsay.com

@Shelton_Whimsy

Lorijo Manley is an award-winning actress, writer, and performing singer-songwriter musician, whose projects include The Lorijo Manley Manly Man Band and six recordings, with a seventh on the way. She is currently working on a book that has nothing to do with the arts.

www.lorijomanley.com

MariNaomi is a cartoonist and podcaster whose work includes the graphic memoir *Turning Japanese*, the YA series *Life on Earth*, and the podcast *Ask Bi Grlz*. She created and maintains the databases Cartoonists of Color, Queer Cartoonists, and Disabled Cartoonists.

marinaomi.com

@marinaomiart

Liz Mason is a writer and performer, and publishes zines with names like *Caboose* and *Cul-de-sac*. Her work has also been published in such publications as *Broken Pencil*, *Punk Planet*, *The Zine Yearbook*, and more. She is the manager of Quimby's Bookstore, home of wild and weird reading material in Chicago, where she has worked since 2001.

LizMasonIsAwesome.com

@CabooseZine

Winter Miller is a playwright who lives with Brooklyn in her cat Gato.

wintermiller.com

Mimi Pond is a veteran cartoonist whose books include the graphic novels *Over Easy* and *The Customer is Always Wrong*. She is currently at work on a graphic novel about the Mitford Sisters.

mimipond.com

@mimipondovereasy

Heather Riordan has no idea what she wants to do when she grows up. She has worked as an actress, writing and performing in The Neo-Futurists' *Too Much Light Makes The Baby Go Blind*, and other shows for twenty years. She plays accordion solo and with the band The Crooked Mouth, and a yet untitled duo with her horn-playing fiancé. In her other life, Heather is a Licensed Registered Dietitian, Health Coach, and personal fitness trainer, and still teaches fitness classes.

thecrookedmouth.org

@AccordionHeather

Akin Salawu is a playwright and the founder of LIT Council, a development intensive for Male Playwrights of Color.

thetanknyc.org/lit-council

@Akinscribe5

Christine Schisano is a puppeteer, puppet designer, actor, writer, and producer. Her performing credits include *The Gilded Parable* at the Eugene O'Neill National Puppetry Conference, *Sallie Mae: Loan Me Your Soul*, *Dear Tina: I'm Wearing a Wig*, *The Completely True Tales of Boris the Peacock*, and *Le Bijou Lady*. Her design credits include *VEIL'D* and *Discouraging Stories For Lonely People*.

christineschisano.com

Trav S.D. is a writer and performer, best known for his books *No Applause, Just Throw Money: The Book That Made Vaudeville Famous*, *Chain of Fools: Silent Comedy and Its Legacies from Nickelodeons to YouTube*, and *Rose's Royal Midgets and Other Little People of Vaudeville*, as well as his blog, Travalanche. He is most proud of having produced and directed the first ever revival of the Marx Brothers' first Broadway show *I'll Say She Is*, adapted by Noah Diamond. He has been making indie theater in NYC since 1989.

travsd.wordpress.com

R. Sikoryak is a cartoonist and author of the graphic novels *Constitution Illustrated*, *The Unquotable Trump*, *Masterpiece Comics*, and *Terms and Conditions*. Sikoryak teaches at Parsons School of Design. Since 1997, he's presented his live comics performance series, Carousel, around the U.S. and Canada.

rsikoryak.com

@rsikoryak

Ben Snakepit is the creator of Snake Pit Daily Diary Comics.

bensnakepit.com

@Bensnakepit

Stephanie Summerville is an actress, speaker, and storyteller, most known for her work with the Moth, a live storytelling events organization, and The Moth Radio Hour on NPR. Most recently, Stephanie has been featured on the BBC Radio Program, *Outlook*. When not circling the globe on ships as a cruise director, she lives as a nomad, declaring home to be "wherever I hang my hat."

Steven Svymbersky has been publishing zines since 1985. He is the founder of Quimby's Bookstore in Chicago (1991) and Quimby's Bookstore NYC in Brooklyn (2016).

@quimbysbookstorenyc

Edward Thomas-Herrera is a poet, performer, and playwright living and working in Chicago. He was once approached by *American Theatre* magazine to be featured in an article titled "30 THEATRE ARTISTS UNDER 30" only to have the offer rescinded when it was discovered he was thirty-two years old at the time.

@me_llamo_Edward

Anthony Wills, Jr. is an artist, karaoke enthusiast, artistic director of Artistic Pride Productions

and human advisor to the International Puppet Theater of the Planet Earth.

anthonywillsjr.com

J.T. Yost is a small potato farmer praying for rain but desensitized to drought. His crops include Birdcage Bottom Books (a small comics press and distro), freelance illustration work, pet portraiture, a beloved wife, two sprouting offspring, and a complacent canine. After his children, he is most proud of editing and publishing the addiction-themed comics anthology *BOTTOMS UP: True Tales of Hitting Rock-Bottom!*

birdcagebottombooks.com

jtyost.com

honorthypetportraits.com

@birdcagebottom

Additional illustrations by Maria Camia, Bryce Edwards, Ben Snakepit, and J.T. Yost, with permission of the artists.

Thank you to Joe Biel, Elly Blue, Lex Orgera, Sophie LeGrand, Alana Baldwin-Joiner, Esa Grigsby, the staff and interns of Microcosm Publishing, the staff of the New York Society Library, everyone who kicked in to our crowdfunding campaign, Kotis Kotis & Kotis, everyone who's supported or participated in my creative efforts over the years, and the thirty-seven towering small potatoes whose experience, outlooks, and advice shaped this Manifesto.